IMAGES
of America
NEW YORK CITY
IN THE CIVIL WAR

On the Cover: This June 1865 photograph by Jeremiah Gurney and Son depicts patients at the US Ladies' Home for Sick and Wounded Soldiers at Lexington Avenue and Fiftieth Street. (Terry Alphonse, Alphonse Gallery.)

IMAGES *of America*
NEW YORK CITY IN THE CIVIL WAR

Jonathan W. White and Timothy J. Orr
Foreword by Harold Holzer

Copyright © 2024 by Jonathan W. White and Timothy J. Orr
ISBN 978-14671-6157-2

Published by Arcadia Publishing
Charleston, South Carolina

Printed in the United States of America

Library of Congress Control Number: 2024946792

For all general information, please contact Arcadia Publishing:
Telephone 843-853-2070
Fax 843-853-0044
E-mail sales@arcadiapublishing.com

Visit us on the Internet at www.arcadiapublishing.com

For our professors at Penn State—especially Bill Blair, Mark Neely, and Carol Reardon of the Richards Civil War Era Center—who introduced us to each other in 2002 and who helped guide our paths toward becoming professional historians.

Contents

Foreword		6
Acknowledgments		7
Introduction		8
1.	On the Verge of Disunion	9
2.	The Secession Crisis	23
3.	Mobilizing for War	39
4.	New York City's Boys in Blue	53
5.	Street Scenes and Social Life	67
6.	Politics and Politicians	81
7.	Destroying the Atlantic Slave Trade	95
8.	The Draft Riots	105
9.	Gotham's Black Soldiers	119
10.	The Great Metropolitan Fair	133
11.	The Election of 1864	143
12.	A City's Memories of War	153

Foreword

Two days before Washington's birthday in 1861, President-elect Abraham Lincoln crossed New York's busiest thoroughfare, Broadway, and entered City Hall to attend a reception in his honor. His host was Mayor Fernando Wood, a secession-sympathizing Democrat who hoped to take New York City—at the time consisting of Manhattan and the Bronx (not Brooklyn)—out of the Union as a free port commercially aligned with the slave-holding South. Lincoln ascended City Hall's interior staircase to the second floor and into the so-called "Governor's Reception Room," part of a suite reserved for the state's chief executive when working in the city. Here, Lincoln stood face to face with Mayor Wood, separated by an antique desk George Washington himself had used as president. Wood then stunned the crowd by publicly urging "fraternal relations between the states"—continued trade with the Confederacy. Obliquely, Lincoln replied that he would never consent to "the destruction of the Union." Privately, he added a folksy pledge: he would never let the nation's front door set up housekeeping on its own.

New York would remain in the Union—though its residents never supported Lincoln politically and though its streets erupted in violence two years later in protest against the military draft. Otherwise, life in the nation's largest city went on as it had before the rebellion: focused on retail commerce, high finance, shipping, and the quest of its working class to survive and thrive.

This book attests in vivid pictures and expert text to what New York and New Yorkers looked like—indeed, felt like—during this roiling era. Here are the imposing landmarks and sordid slums as well as municipal poohbahs, visiting celebrities, and the ordinary people who labored in factories and on the docks. Here too are the military parades, rallies, fundraisers, and funerals that reminded inhabitants they were living through a time of upheaval. Of all the books about the Civil War home front, few have so dramatically revealed a city at war with itself.

As for Lincoln, he would return to New York in April 1865, again the center of attention at the threshold of that same Governor's Reception Room in City Hall. Here, now a martyr, he would lie in state.

—Harold Holzer

Acknowledgments

We thank the many people who helped make this book a reality. At the New York Public Library, Kelly Filreis and David Lowe assisted with locating images, as did Carrie Feldman of the Smithsonian's National Museum of African American History and Culture. Ron Coddington helped us track down obscure images, and collectors Terry Alphonse, Thomas Harris, Trudy B. Hawley, Roger Hunt, Chuck Joyce, Michael Waricher, Brian White, and Don Wisnoski graciously permitted us to use images from their collections. Laura Orr read the manuscript and offered helpful suggestions for improvement. The Department of Leadership and American Studies at Christopher Newport University (CNU) provided funding to pay for image permissions. And the Center for American Studies at CNU supported research assistance by students Reagan Connelly and Lainey Pratzner.

A number of archival collections are acknowledged throughout the book with abbreviated citations. These are (in alphabetical order): Abraham Lincoln Presidential Library and Museum (ALPLM), Archive.org (AO), Google Books (GB), the collection of Jonathan W. White (JW), the Prints and Photographs Division of the Library of Congress (LOC), the Lincoln Financial Foundation Collection of Fort Wayne, Indiana (LFFC), the National Archives and Records Administration (NARA), the Naval History and Heritage Command (NHHC), the Smithsonian Institution's National Portrait Gallery (NPG), the New-York Historical Society (NYHS), the Miriam and Ira D. Wallach Division of Art, Prints, and Photographs at the New York Public Library (NYPL), and the New York State Military Museum (NYSMM).

Finally, we thank Kate Jenkins, Jeff Ruetsche, and Amy Jarvis of Arcadia Publishing for their support of this project.

Introduction

Buried on the fifth page of the October 20, 1862, edition of the *New York Times*, under the headline "Brady's Photographs," began a report: "The living that throng Broadway care little perhaps for the Dead at Antietam, but we fancy they would jostle less carelessly down the great thoroughfare, saunter less at their ease, were a few dripping bodies, fresh from the field, laid along the pavement. There would be a gathering up of skirts and a careful picking of way; conversation would be less lively, and the general air of pedestrians more subdued." The reporter noted that New Yorkers often read "a confused mass of names" of casualties in the papers, but that those names were typically forgotten by the time they drank their morning coffee. "We recognize the battle-field as a reality," continued the *Times*, "but it is a remote one."

The famed New York photographer Mathew Brady brought the carnage of the battlefield to the home front when he opened an exhibition of photographs taken at Antietam shortly after the bloody battle of September 17, 1862. Crowds of people entered Brady's building at 643 Broadway to gaze at "The Dead of Antietam." These pictures brought out a "terrible fascination" and cast a "strange spell" among the many New Yorkers who bent down to look into the pale faces of the dead. Taken on a battlefield more than 200 miles away, these graphic pictures brought civilians face-to-face with the terrible cost of the war.

And yet many aspects of New York City life continued as if the war were not taking place. The *Times* report captured the hustle and bustle on Broadway on any given day in 1862—the lively conversations that took place as men and women sauntered carelessly down the streets to their favorite shops, restaurants, and theaters. Throughout the war, New York City remained the center of commerce, culture, and politics in the United States. Newspapers reported on the social events taking place in the city, and illustrated magazines kept readers informed on the latest fashions and literature.

Once the war began, the city became the center of military mobilization in the North, supplying more soldiers for the Union than any other metropolitan area. Black leaders mobilized African American support for the war there, and immigrants raised celebrated ethnic regiments. Charitable organizations put on marvelous events to raise money for the troops. In addition, the city was an entrepot that provided uniforms, weapons, supplies, medical care, and safe harbor for naval vessels. It was a vital engine that powered the North's Civil War.

Yet, New York was also a deeply divided city where political differences were hashed out—sometimes violently. Nationally renowned newspapers debated the pressing issues of the day. The city's moneyed class had strong ties to the South, and in some cases, editors had their newspapers shut down for disloyalty. And for four days in July 1863, the streets of Manhattan were awash in blood as a white mob took out its vengeance on the city's African American community.

The people of New York City captured the diversity of America in terms of race, ethnicity, religion, politics, and social class. Modern Americans cannot understand the American Civil War without understanding New York City's role in the conflict. Fortunately, the city was also the most photographed and illustrated locale of the war. Photographs and newspaper illustrations from the 1860s still cast a "strange spell" and elicit a "terrible fascination" even now, as they did when New Yorkers stepped into Brady's gallery in 1862. Our hope is that the images in this book will bring Civil War New York back to life for readers, helping recapture how residents of the city experienced the turbulence, triumphs, and suffering of the war.

One

On the Verge of Disunion

New Year's Day 1860 dawned in New York City with great hope. "January, A.D. 1860!" trumpeted Horace Greeley's influential newspaper, the *New-York Tribune*. "How far along it seems! To what a golden era and bounteous land has the flowing river of time borne us! And to what a stately city—the third city of Christendom—at whose extreme southern point, only two hundred and thirty-seven years ago, was laid the first stone of the rude fort that should protect a little Dutch settlement of only a dozen quaintly-gabled houses." But now, New York City was second only to London for its prominence in the world.

Between 1850 and 1860, the population of New York City had exploded by nearly 60 percent, from 515,547 to 814,254 inhabitants. The 10 counties surrounding Manhattan had also grown from 380,000 to 690,000 during that period—making the total population for the metropolitan area about five percent of the entire US population. A hub of manufacturing and commerce, nearly two-thirds of imports came through the docks along the Hudson and East Rivers, while more than one-third of American exports went out to the world through Manhattan shipping.

The year 1860 would also see incredible political and social excitement, including visits from foreign dignitaries, massive parades, and, in February 1861, the passage of the president-elect through the city on his way to Washington, DC.

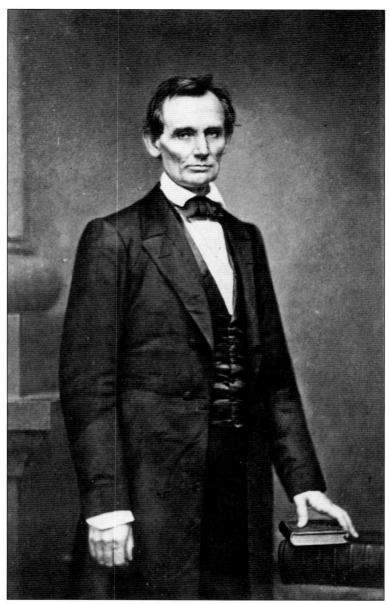

In February 1860, Abraham Lincoln traveled to New York City, where he delivered an address at the Cooper Union that urged Republicans to hold firm to their antislavery principles in the face of immense political opposition. One person who watched Lincoln from the stage later recalled that Lincoln's "voice was unpleasant, almost rasping and shrill at first," but "his earnestness invited and easily held the attention of his auditors." Although he looked clumsy and ungainly, "after he began to talk he was awkwardness deified." Fully aware of the power of photography, Lincoln also stopped by Mathew Brady's studio while he was in town to have his portrait taken. When the famous photographer raised Lincoln's collar, Lincoln joked, "I see you want to shorten my neck." "That's just it," replied Brady, and both men laughed. The photograph soon appeared in illustrated newspapers, giving Lincoln a national presence that would help win him the Republican nomination for president in May. (NPG.)

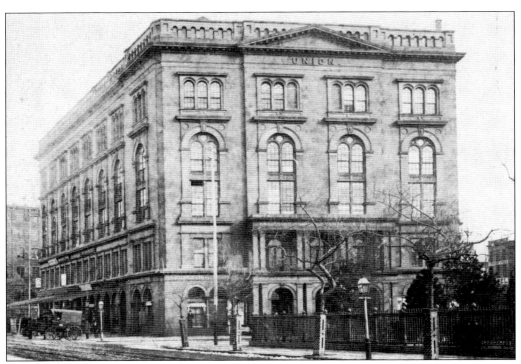

Founded in 1859 by inventor and philanthropist Peter Cooper and located near the intersection of East Fifth Street and Fifth Avenue, the Cooper Union was a popular venue for public lectures during the Civil War. Cooper believed that an education "equal to the best technology schools" that already existed should be "open and free to all." (LOC.)

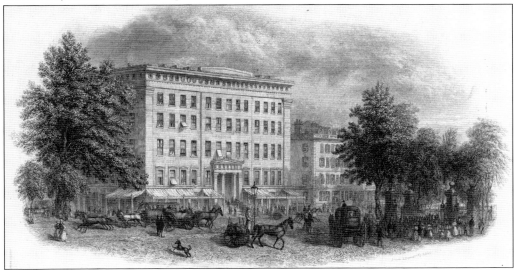

Lincoln stayed at the Astor House, on Broadway between Vesey and Barclay Streets. One young New York Republican visited him there the morning after the Cooper Union address with the "shouts of approbation of the previous night . . . still ringing in my ears, but the figure of the awkward Illinoisan suggested nothing in the way of public enthusiasm or personal distinction. He then and there appeared as a plain, unpretentious man." (LOC.)

On June 16, the Japanese Embassy arrived in New York for the final stop on its diplomatic visit to the United States (it had previously visited San Francisco; Washington, DC; Baltimore; and Philadelphia). Upon arriving at the harbor, citizens calling themselves the "Veterans of '76" fired a salute while a crowd gathered between the depot and Castle Garden to witness the event. (LOC.)

After arriving at Pier 1, the Japanese ambassadors were escorted by 7,000 New York State militiamen up Broadway, Grand Street, the Bowery, around Union Square, and down Broadway to the Metropolitan Hotel. According to the *New York Times*, it took the procession an hour to pass any given point, as spectators crowded on the streets to watch. (LOC.)

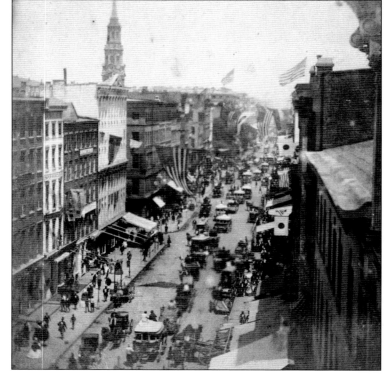

Japanese and American flags flew throughout the city, and the streets were crowded with "eager, jostling, tired, curious" people who patiently waited "for six hours under a sweltering sun" to see the procession. The *New York Times* called the procession "one of the finest displays of the kind ever witnessed in the City." (LOC.)

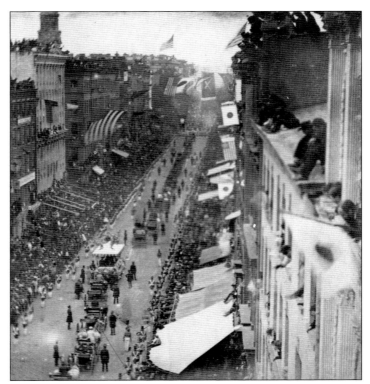

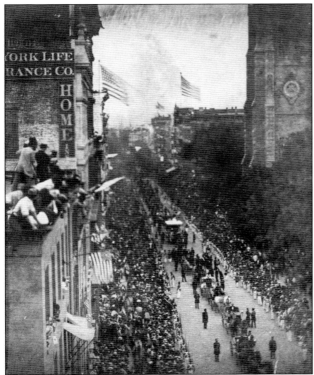

The *New York Times* reported that "every window, house-top, tree, box, awning post, brick pile, fence, and in short every stand point along the route had its tenant; and yet, to the credit of the Police be it said, the procession moved along almost unobstructed through the sea of humanity." At certain places and street corners "the crush was terrible to endure, and fearful to witness." (LOC.)

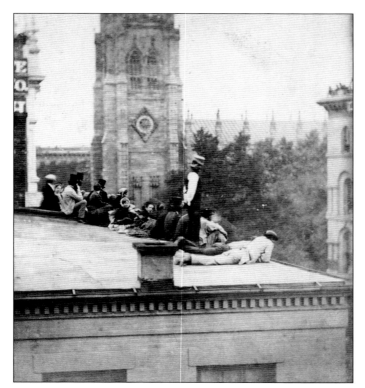

In this photograph by George Stacy, titled "A Good View," spectators watch the procession from a roof on Broadway. Americans were captivated by a 17-year-old Japanese interpreter who traveled with the delegation named Tateishi (Tamehachi) Onojiro but who was affectionately known as "Tommy." The *New York Times* reported that he wore a pair of pants that had "a particularly 'loud' pattern" that captured the attention of the spectators. (LOC.)

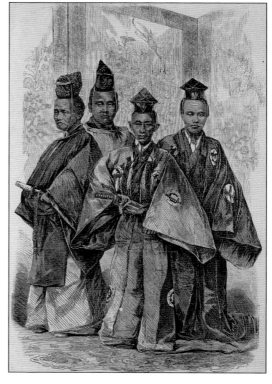

Frank Leslie's Illustrated Newspaper reproduced a photograph by Mathew Brady of several of the Japanese officials. During the procession, the Japanese occupied a stand that was erected for them at Union Square to salute the militiamen as they marched past. In the evening, the diplomats were serenaded by Harvey B. Dodworth's band. (LFFC.)

The Metropolitan Hotel, on the northeast corner of Broadway and Prince Street, was decked out with thousands of Japanese and American flags and illuminated with 2,000 Venetian lamps to welcome its guests. The luxury hotel treated guests to artificial light and running water. This image shows the 7th New York State Militia drawn up outside the hotel on June 18 while the ambassadors enter carriages. (NYPL.)

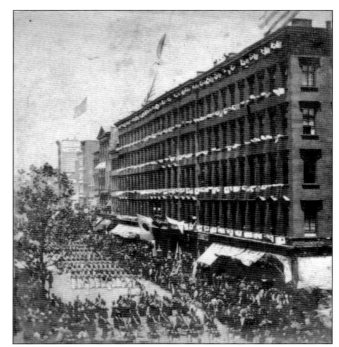

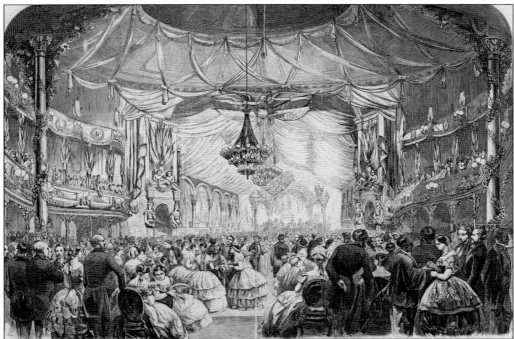

On June 25, the Japanese Embassy enjoyed an extravagant ball at the Metropolitan Hotel. The *New York Herald* reported that "all classes" of citizens were "affected by the mania for tickets, and the rush at the hotel was tremendous." Unfortunately, ticket prices "were so enormous" that many were left "in despair." Throughout the evening, the Japanese visitors "amused themselves" by looking out the windows at pedestrians on Broadway. (NPG.)

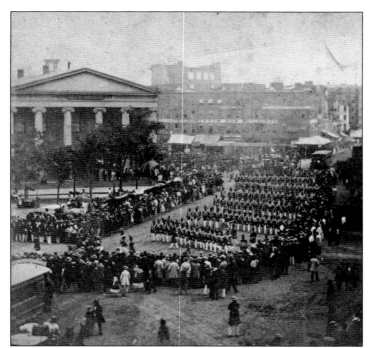

On July 4, 1860, the *New-York Tribune* reported, "Youngsters made the whole city . . . noisy and sulphurous," while "older people everywhere" went on excursions "out of town, among the meadows or by the ocean shore." Those who remained in the city enjoyed a "merry" military parade by the 1st Division of the New York State Militia, seen here marching past the Hall of Records to City Hall Park. (LOC.)

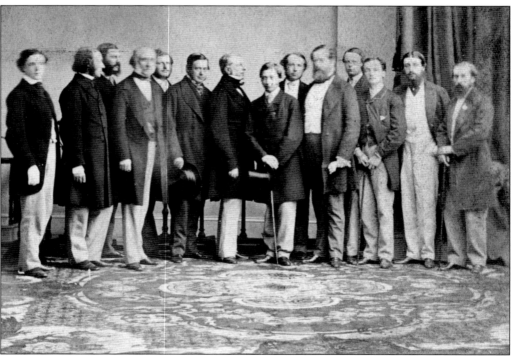

As part of his visit to Canada and the United States, Albert Edward Renfrew, the 19-year-old Prince of Wales, made a three-day visit to New York City. The eldest son of Queen Victoria and Prince Albert, the prince would ascend to the throne 41 years later as King Edward VII. This Mathew Brady photograph shows him (at center with a top hat and cane) with his entourage. (LOC.)

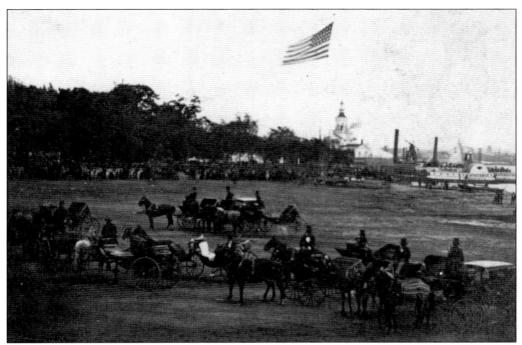

The prince arrived in Manhattan on Thursday, October 11. An enormous crowd went to the Battery to witness his arrival. Dressed in a British colonel's uniform, Prince Albert then inspected the New York State Militia regiments that had assembled at the Battery to greet him. After the review, the prince, mayor, and others processed from Bowling Green up Broadway. The *New York Times* reported that "never before have we seen such a surplusage of bunting, such a superfluity of flags, such strange combinations of quasi-national colors and designs, as were protruded on poles out of all the windows and hoisted over all the chimney-tops of aspiring trade." (Above, LOC; below, LFFC.)

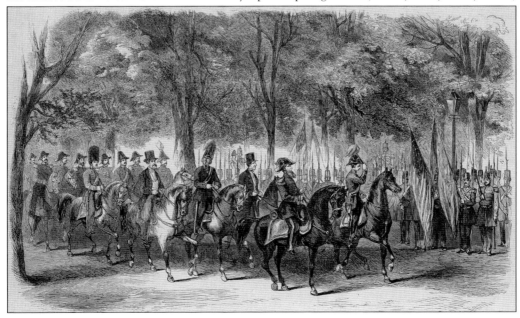

Many wealthy New Yorkers, including Mayor Fernando Wood, vied to have the prince stay at their private residences. Eventually, the Fifth Avenue Hotel, which was located at Fifth Avenue and Twenty-Third Street, was selected as a suitable neutral location. On the second day of his visit, the prince toured New York University, the Astor Library, the Cooper Union, and Central Park. (LOC.)

On October 12, the prince attended a ball at the Academy of Music, at the northeast corner of Fourteenth Street and Irving Place. Twenty-eight hundred tickets were sold for $10 each. The ballroom floor was so crowded that it collapsed just before the prince began his first dance. Carpenters quickly repaired the damage, and fortunately no one was injured, although it delayed the start of the dancing until close to midnight. (LOC.)

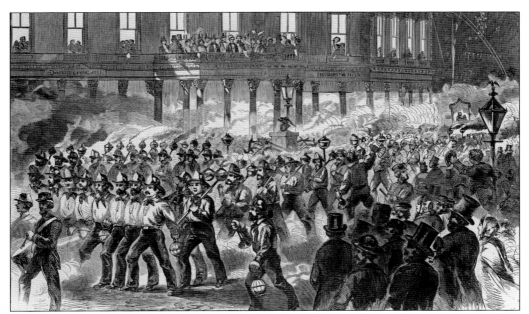

After touring Barnum's Museum on Broadway on Saturday, October 13, the prince returned to the Fifth Avenue Hotel, where he stood on a balcony and watched a grand torch light procession of New York City firemen march by with their engines lit up with transparencies in his honor. One of the prince's companions later noted, "The procession extended several miles, and was one of the finest sights ever witnessed." (LOC.)

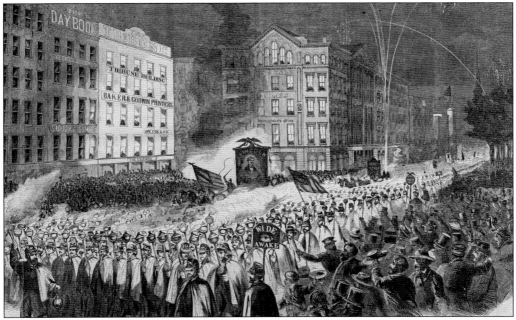

On October 3, thousands of farmers filled New York City's hotels to witness the Wide Awake demonstration. That night, while traveling up Broadway toward Union Square, a reporter for the New York Times witnessed "living walls of American man-and-womanhood." Casting a glance toward the East River, Fourteenth Street appeared to be "solidly paved with flaming torches." (JW.)

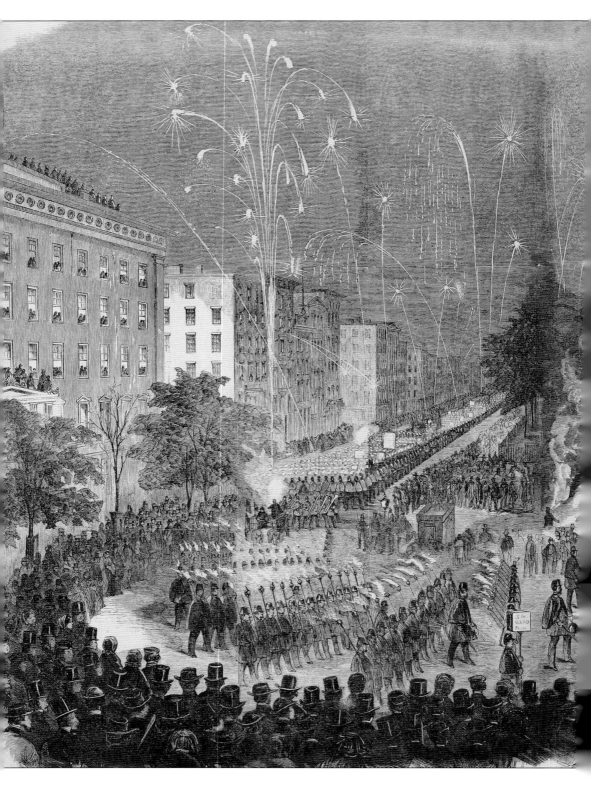

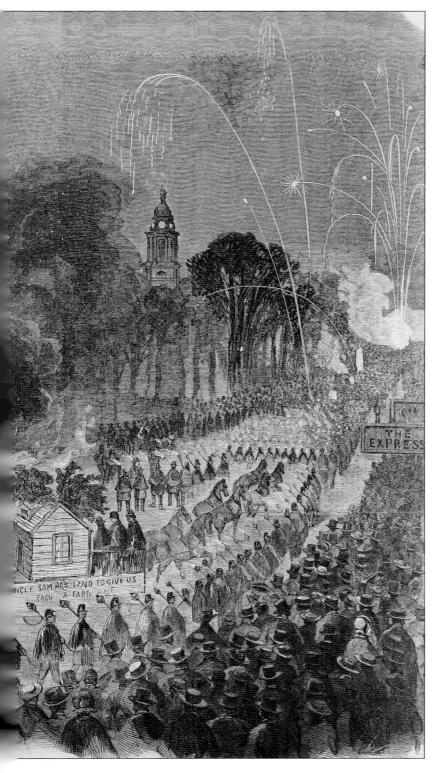

The Wide Awakes pulled cannons, carried banners, played the fife and drum, and shot colorful fireworks into the sky. At midnight, a reporter for *Harper's Weekly* standing near the corner of Broadway and Tenth Street "saw the entire street sheeted with flickering light." This image, which appeared in *Frank Leslie's Illustrated Newspaper*, depicts the procession as it passed through City Hall Park. In it, the Wide Awakes push a float of a farmhouse with a banner that reads, "Uncle Sam Has Land Enough to Give Us Each a Farm." As many as 12,000 marchers participated in this grand affair. Many of these young, energetic, militarized men would go on to volunteer in New York regiments after the South seceded from the Union. (LFFC.)

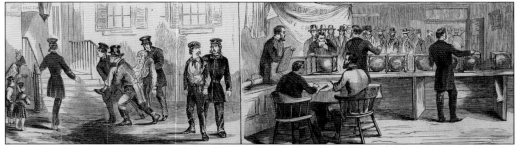

On November 6, voters went to the polls. Four candidates vied for the presidency—Lincoln the Republican, Sen. Stephen Douglas of Illinois as the Northern Democrat, Vice Pres. John C. Breckinridge as the Southern Democrat, and John Bell of Tennessee as the Constitutional Union candidate. Election Day was mostly peaceable, as can be seen in this polling place (right), although some voters were arrested for drunkenness (left). (LFFC.)

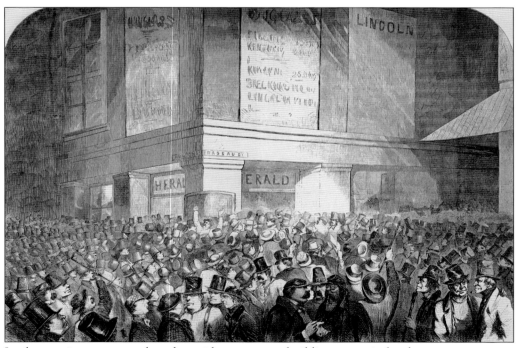

In the evening, voters gathered outside newspaper buildings to wait for the returns to come in across the telegraph line (here they stand outside the *New York Herald* building). Nationally, Lincoln won less than 40 percent of the popular vote, but he easily won the Electoral College. In the Democratic stronghold of New York City, Lincoln carried only 33,290 out of 95,583 votes cast in the four-way race. (LFFC.)

Two

THE SECESSION CRISIS

On December 20, 1860, with the publication of South Carolina's Ordinance of Secession, the United States began the so-called "secession winter." As state after state severed its connection with the Union, New York City's anxiety intensified. The city's two-to-one Democratic majority ensured that a sizable portion expressed sympathy with the rebellious states. The bulk of the city's voters blamed the Republican Party for the nation's unnatural division. Unfairly, editor James Gordon Bennett of the *New York Herald* complained that the party's "vicious, imbecile, demoralized administration" had caused the disunion sentiment. He surmised that it would be far better for the Union to be "dismembered forever, than that fraternal hands should be turned against one another, to disfigure the land by slaughter and carnage."

Such bitterness did not persist. In April, news from Fort Sumter injected the city with a common cause. Those who earlier expressed sympathy for the slave states suddenly transformed into the strongest supporters of the Union. The *Times* mused, "Party bonds flashed into nothingness in the glowing flame of patriotism. . . . Nothing for years has brought the hearts of all the people so close together—or so inspired them all with common hopes, and common fears, and a common aim, as the bombardment and surrender of an American fortress." Everywhere, people came out of their doors and waved flags, encouraging young men to don uniforms, shoulder their weapons, and march off to war.

For the remainder of the spring, the city mobilized its state militia regiments and rushed them off to the front. Although several regiments performed well during their first combat, the defeat at Bull Run on July 21, 1861, filled the city with a collective sense of shame. One of the premiere regiments—the 11th New York Fire Zouaves—had been routed, and 14 others had been caught up in the retreat. The day after Bull Run, Wall Street lawyer George Templeton Strong noted in his diary: "Today will be known as BLACK MONDAY. We are utterly and disgracefully routed, beaten, whipped by secessionists."

President-elect Abraham Lincoln arrived in New York City at 3:00 p.m. on February 19, 1861. He and his entourage detrained at the city depot, which took up the block on Thirtieth Street between Ninth and Tenth Avenues. Men, women, and children of all ages gathered to see the president-elect. After Lincoln departed his train, the crowd doffed their hats and cheered and then rushed onto the train car to try to sit in Lincoln's seat. (LFFC.)

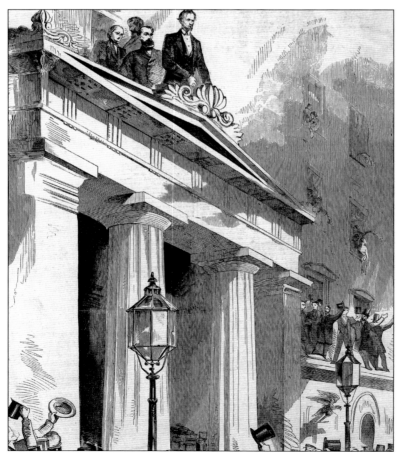

After Lincoln left the train station, a crowd assembled at the Astor House, located at the corner of Broadway and Vesey Streets. Some climbed trees and lampposts to get a glimpse. As the *New York Times* reported, the crowd was "impenetrable," and Lincoln made it through the entrance and lobby only with the assistance of police. Induced by the cheering, Lincoln stood atop the portico to address the crowd. (LFFC.)

When the Civil War began, Fernando Wood was serving his third term as mayor. Sympathetic to the Southern cause, Wood proposed that New York City take steps to declare itself a "free city," independent from the Union. When Lincoln arrived, Wood held a tense reception for him at City Hall. In his welcoming address, Wood suggested restoration of the "fraternal relations between the States" but only through "peaceful and conciliatory means." (NARA.)

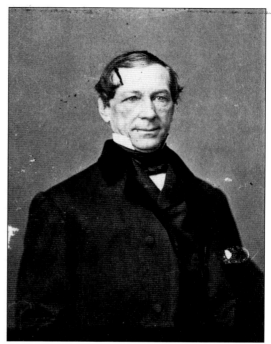

Lincoln met with Mayor Wood inside City Hall at 11:00 a.m. on February 20. In this illustration, Wood stands behind the rosewood table, palm open. Lincoln stands opposite, stovepipe hat in hand. According to a reporter, "The appearance of the two men was striking enough for a picture." After spending two days in New York with only a handful of speaking events, Lincoln left via the Cortlandt Street Ferry. (LFFC.)

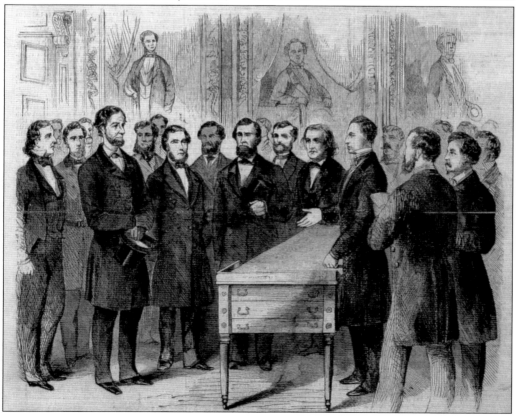

Maj. Robert Anderson commanded the garrison at Fort Sumter. On April 19, the steamer *Baltic* carried his troops to Governors Island, while Anderson arrived in Manhattan, taking with him the flag that had flown atop the fort. Keeping a low profile, Anderson stayed at the Brevoort House, at the corner of Eighth Street and Fifth Avenue. This photograph was likely taken on the morning of April 20 at Jeremiah Gurney's gallery. (LOC.)

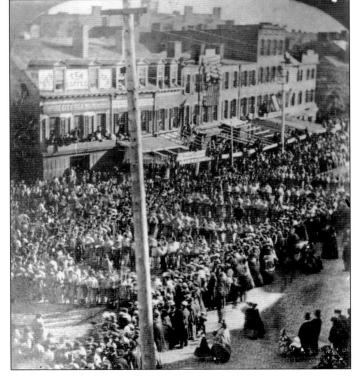

Under orders from the governor, at 3:00 p.m. on April 19, the members of the 7th New York State Militia (the 7th New York National Guard when under federal control) assembled at their armory at Tompkins Market in preparation for transit to the front. Eager to behold their departure, thousands of well-wishers mobbed the regiment's inspection on the Bowery near the Cooper Union building (depicted here). (NYHS.)

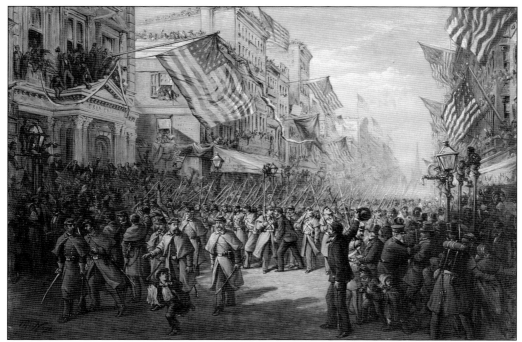

After leaving Lafayette Place, the 7th New York State Militia paraded down Broadway, which was packed elbow to elbow by an excited throng. A reporter wrote that the soldiers marched through a crowd "so dense that it seemed to block up the way impassibly." After passing in review before Maj. Robert Anderson, the regiment reached the Cortlandt Street Ferry, boarded boats, and crossed the Hudson River. (NYSMM.)

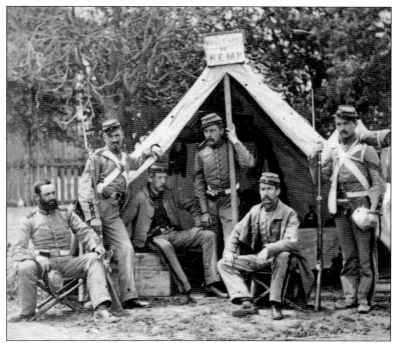

The 7th New York State Militia reached Washington, DC, on April 25, where it received personal thanks from Abraham Lincoln. Two days later, the militiamen mustered into federal service for 30 days. On May 1, the regiment bivouacked at Camp Cameron, a 40-acre plot along the Harpers Ferry Road two miles from the Capitol. This image depicts six enlisted men in front of their A-frame tent at that location. (LOC.)

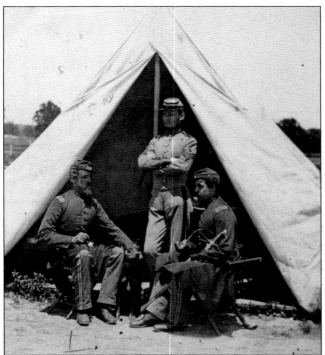

Here, company staff from the 7th New York enjoy a picturesque day at Camp Cameron. The men in this image are unlabeled, but they are probably Capt. Emmons Clark (petting dog), 1st Sgt. Peter Palmer (standing), and 2nd Lt. Edward Bernard (holding pipe). The 7th New York departed Camp Cameron on May 31, and it returned to New York City on the evening of June 1. (LOC.)

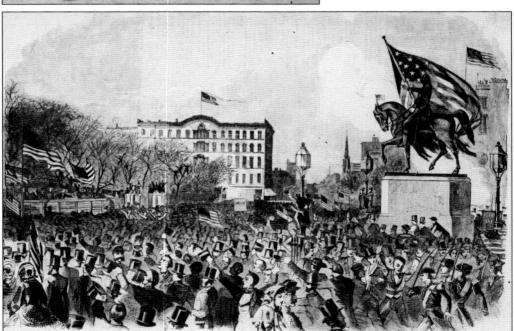

On April 20, 1861, over 200,000 people gathered at Union Square to hear speeches affirming the city's commitment to defeating secession. Spectators saw Maj. Robert Anderson and the members of the Fort Sumter garrison, and they beheld the American flag that had flown above the fort. This *Harper's Weekly* sketch features the 1856 equestrian monument to George Washington sculpted by Henry Kirke Brown. (LFFC.)

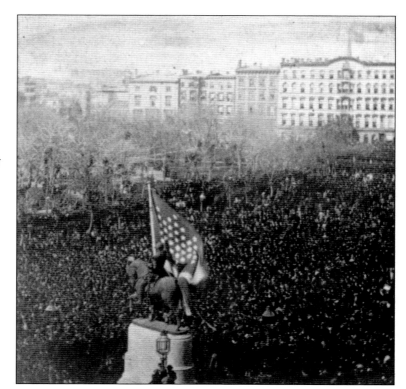

Presentations a the April 20 rally lasted over three hours, from 3:00 to 6:00 p.m. Although the audience heard different speeches depending upon their location, everyone in attendance received the same message: the Union must be preserved, and New York City must provide the men and money to do it. The editor of the New York Herald commented that the "Monster Meeting" proved "beyond all cavil that there was but one sentiment in New York. The united demonstration of the 20th of April will live forever in the world's history." These photographs depict the massive crowd covering Fourteenth Street, which crosses the top image from the left foreground into the right background. The conspicuous five-story Everett House can be seen in the background with a flag flying over its roof. The equestrian monument to George Washington stands prominently in the foreground. It supports the flag that flew above Fort Sumter. (Both, NYHS.)

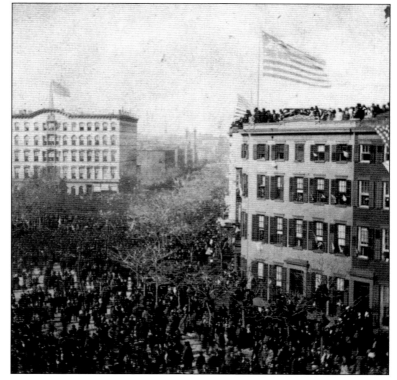

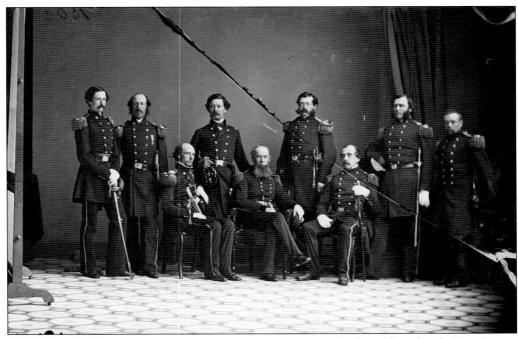

At the war's outbreak, Maj. Gen. Charles W. Sandford commanded the New York State Militia's 1st Division, which contained all of the city's militia regiments. Although Sandford had seen little combat, he had earned a reputation for poise, having led the militia through several prewar riots. During the Confederate rebellion, he supervised the militia's mobilization, offering his services to the federal government. Here, Sandford is seated at center, surrounded by his staff. (LOC.)

Irish-born Col. Michael Corcoran commanded the 69th New York State Militia. On October 11, 1860, he refused an order to assemble his regiment to honor the visit by the Prince of Wales, which resulted in his arrest. Confederate forces captured him at Bull Run, and after a year in custody, he was exchanged and promoted to brigadier general. On December 22, 1863, he died after falling from his horse. (NARA.)

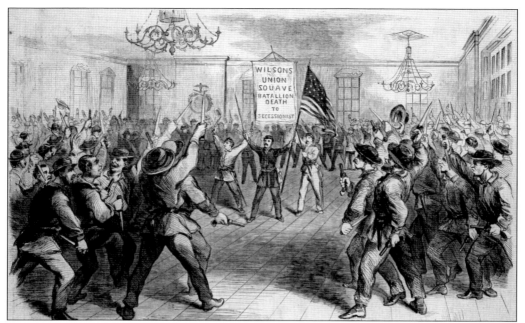

On April 24, soldiers belonging to Billy Wilson's Zouaves—the 6th New York Volunteer Infantry—held a bizarre ritual at Tammany Hall. Enraged by news of the Baltimore Riot, they showed up with revolvers and bowie knives, chanting, "Death to the Plug Uglies!" At the end of their oath of allegiance, the Zouaves replied with cheers of "Blood! Blood! Blood!" (LFFC.)

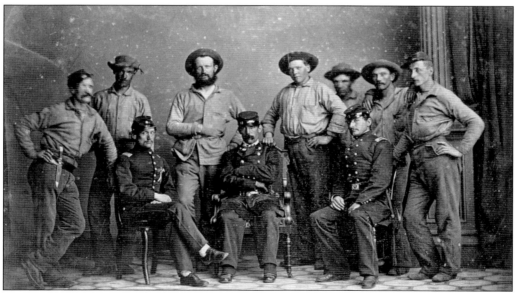

This photograph depicts three officers and seven enlisted men from the 6th New York, a regiment that contained a healthy population of pugilists, criminals, and shoulder-thumpers. The commander, Col. Billy Wilson (seated, center), was an English immigrant who earned fame as a prizefighter, immigrant runner, and alderman. Other Union officers routinely castigated Wilson's Zouaves for their persistent debauchery and misconduct. (NARA.)

On May 24, 1861, Col. Elmer Ellsworth led the 11th New York Fire Zouaves in a deadly publicity stunt. In Alexandria, he spotted a secessionist flag atop the Marshall House Hotel. Declaring "That flag must remain there no longer," he led a squad up to the roof. On the way back down, Ellsworth and his escorts encountered innkeeper James Jackson, who fired a shotgun into Ellsworth's chest, killing him. (Chicago History Museum.)

Ellsworth's avenger was Troy-born Pvt. Francis Edwin Brownell, a member of New York City's Hose Company 42. During the ill-fated flag capture, he returned fire and then lunged with his bayonet, killing Jackson. This publicity shot, taken at an army relief bazaar in Albany, depicts Brownell in his Fire Zouave uniform. The sign, "Marshall House Flag," points to a display of the flag that he and Ellsworth captured. (LOC.)

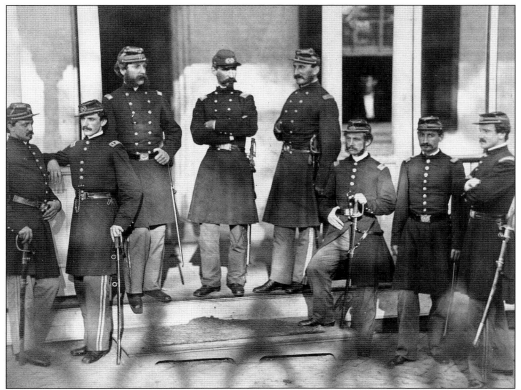

This photograph, from June or July 1861, depicts officers of the 71st New York State Militia at the Washington Navy Yard on the Anacostia River. Not all these officers are identified, but some are likely Lt. Col. Charles Smith (third from left), Col. Henry Patchen Martin (fourth from left), and Maj. George Andrew Buckingham (fifth from left). (LOC.)

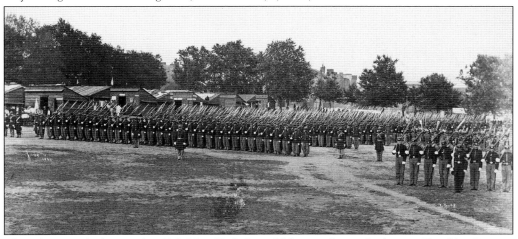

This photograph depicts the 12th New York State Militia at Camp Anderson, Franklin Square, Washington, DC, which it occupied from May 7 to May 23, 1861. The mustachioed officer in front is Col. Daniel Adams Butterfield, a businessman who became famous for authoring the bugle call "Taps." Butterfield ended the war as a major general, and in 1892, he received the Medal of Honor for heroic service at the Battle of Gaines's Mill. (LOC.)

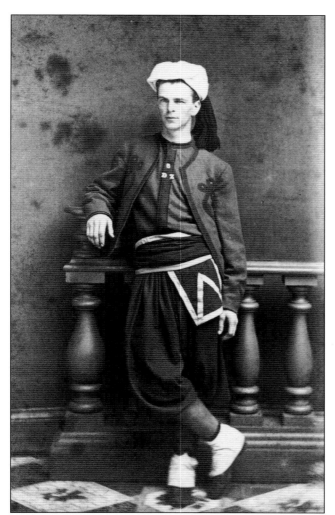

This unidentified soldier belonged to a popular two-year regiment, the 5th New York Volunteer Infantry, commanded by Col. Abram Duryée. This soldier wears the typical uniform of a Zouave: a red and blue shell jacket, a red fez with a turban wrap, red pantaloons, white gaiters, leather *jambiéres*, and a red sash. This soldier wears a brass "5" on his chest to indicate his unit designation and also the letters "D. Z." to indicate "Duryée's Zouaves." (LOC.)

On June 10, 1861, a Union brigade was defeated by Confederate forces at Big Bethel, Virginia. Despite the outcome, the 5th New York Zouaves performed well, and the press lionized them as the first New York City troops to stand the test of combat. The Zouaves rescued the body of 1st Lt. John Trout Greble (2nd US Light Artillery). This illustration depicts a detachment of Zouaves hauling Greble's body atop a caisson. (LFFC.)

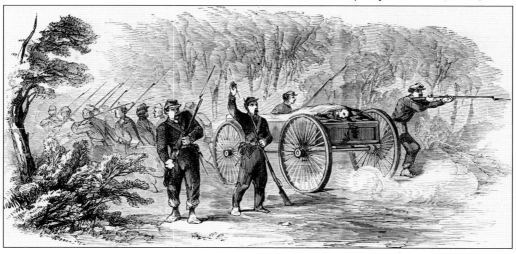

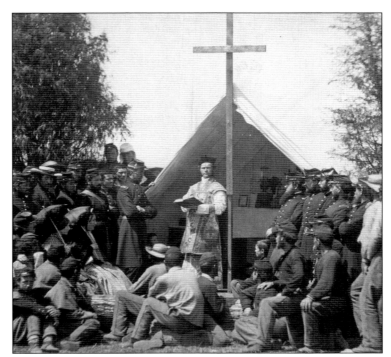

On June 1, 1861, the 69th New York State Militia held Sunday mass at its encampment at Fort Corcoran in Arlington Heights. Fr. Thomas H. Mooney, pastor of St. Brigid's Church (seen in his Catholic regalia), conducted the ceremony. Col. Michael Corcoran stands to the left of Mooney, arms folded. Twelve days later, Mooney was asked to bless an artillery piece but decided to baptize it instead. When he learned of this, a displeased Archbishop John Hughes recalled Mooney. (LOC.)

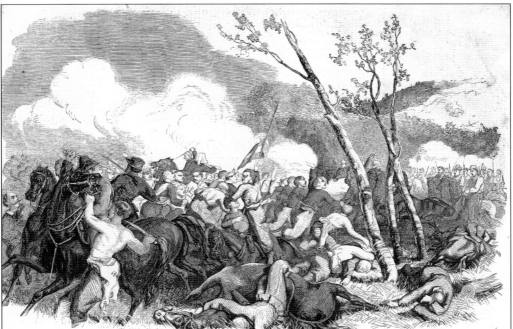

On July 21, 1861, the Union army that defended Washington, DC, suffered defeat at the Battle of Bull Run. Although many regiments were caught up in the panic, national newspapers singled out the 11th New York Fire Zouaves for blame. In the aftermath, some newspaper artists redeemed the Fire Zouaves by depicting their combat in heroic terms. For instance, this illustration distorts events, as it does not show the Zouaves being routed. (LFFC.)

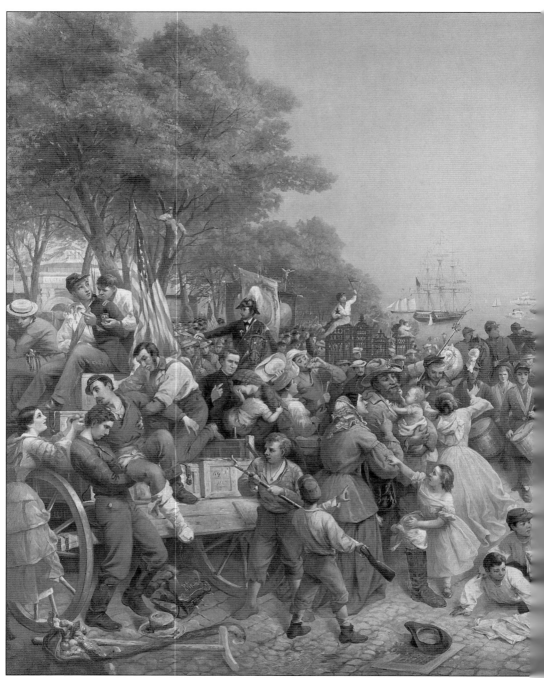

Carried by the steamer *John Potter*, the 69th New York State Militia returned to the city at 6:00 a.m. on July 27, 1861, its three-month tour of duty at an end. It unloaded at Pier 2, adjacent to the Battery. Thousands of citizens rushed to the docks to welcome back the beleaguered veterans. A reporter recalled, "The first soldier who landed was a private, whose little daughter, a child of about six years, clung to him continually, apparently fearing to leave him for a moment." This 1886 painting by Louis Lang depicts the wild scene as the 69th marched from the pier. Lt. Col. Robert

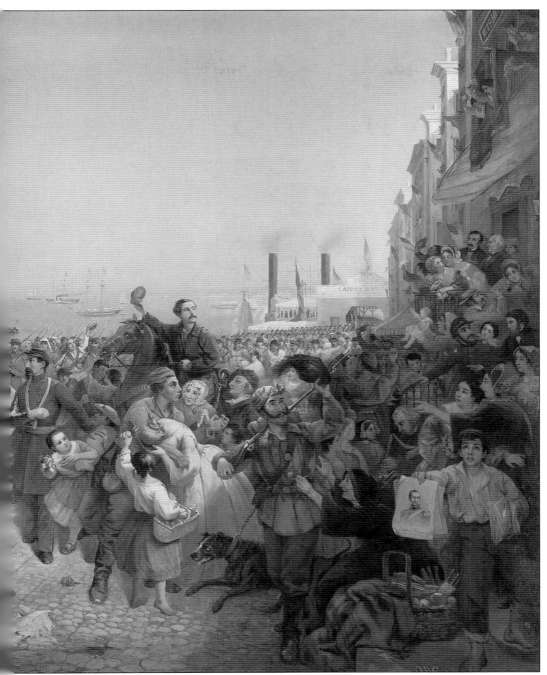

Nugent leads the procession, arm in a sling. Behind him, Capt. Thomas Francis Meagher rides a horse, holding his kepi aloft. At right, a boy circulates images of the 69th's captured commander, Col. Michael Corcoran. So said one Irish American, "No man can have looked at their diminished ranks yesterday without saying to himself that such noble men were deserving of all the thanks a nation can give." (NYHS.)

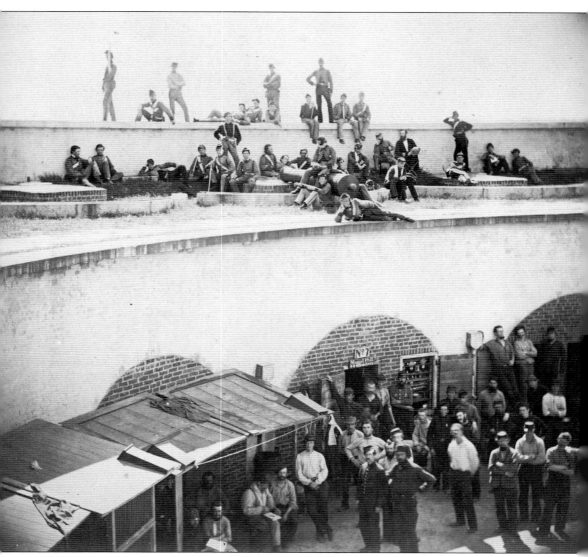

Bull Run produced a frightful casualty list among New York City's regiments, particularly in captured. Initially, Confederate authorities refused to exchange Union prisoners. This photograph depicts one of the early prison camps, Castle Pinckney, a brick fortification inside Charleston Harbor. After spending two months in Richmond, a detachment of 154 prisoners—mostly men from the 11th Fire Zouaves, the 69th State Militia, and the 79th Volunteers—arrived there on September 13, 1861. These New Yorkers—some of them wearing the distinctive uniforms of the 69th New York State Militia—can be seen above. (Note how they labeled their quarters: 444 Broadway.) The prison guards—members of the Charleston Zouave Cadets—are sprawled across the parapet above. (LOC.)

Three

Mobilizing for War

As the largest city in the United States, New York City had to support manpower recruitment. In order for the Union to field a sizable army, the people of New York had to recruit, muster, and organize their volunteers into disciplined companies, regiments, and batteries.

But raising troops was not the city's only wartime requirement. As a metropolis that had already embraced the Industrial Revolution, New York City also had to supply the Union's requisite materiel: uniforms, accouterments, weapons, ammunition, tents, hospitals, medical supplies, and US Navy warships. Throughout the war, the city's factory workers tirelessly produced "equipage," the 19th-century term for military equipment.

Finally, New Yorkers also engaged in mobilization of popular will, the effort to convince all citizens to make sacrifices on behalf of the nation's wartime interest. Accordingly, thousands of New Yorkers donated money to societies that aided soldiers and their families. In August 1864, one newspaper guessed that city residents had doled out $7 million in enlistment bounties and $11 million in voluntary donations. Others, those without deep pockets, volunteered at hospitals to provide medical aid for the sick and wounded. Citizens held elaborate ceremonies to present departing regiments with flags. Some held homecomings for returning veterans, and still others held religious gatherings to honor the memories of the fallen.

Yet immense trial and tribulation attended the process of providing men, equipment, and moral support to the armies of the North. Needless competition caused by political partisanship delayed the passage of regiments to the front. Political corruption slowed the pace of recruiting and provisioning. Criminal behaviors perpetrated by greedy bounty jumpers and bounty brokers fleeced benevolent agencies out of hundreds of thousands of dollars. In many ways, New York City's mobilization effort came up tragically short. Routinely, the city demonstrated an inability to provide its fair share of recruits and equipage. As one frustrated recruiting officer wrote in 1865, "And for this nonsense, the government pays and the war stands still."

Recruiters plastered buildings with posters announcing the formation of new regiments. This poster implores men to join Company I, 5th Excelsior Regiment (74th New York Infantry), which intended to operate as an amphibious force. Specifically, it calls on "Jack Tars," or career mariners. In reality, the 5th Excelsior never did any amphibious work. In April 1862, it embarked with the Army of the Potomac, fighting in some of the Eastern theater's most well-remembered battles. (NYHS.)

This poster, written in German, announces "Sigel's Sharpshooters," or the 3rd Regiment, Brig. Gen. Francis Spinola's Empire Brigade, under the command of Col. Francis X. Braulik. It promises each recruit a $150 state bounty. Sigel's Sharpshooters filled only six companies before mustering in as the 163rd New York Infantry. On January 20, 1863, the War Department disbanded this regiment because it was understrength, consolidating the survivors with the 73rd New York. (NYHS.)

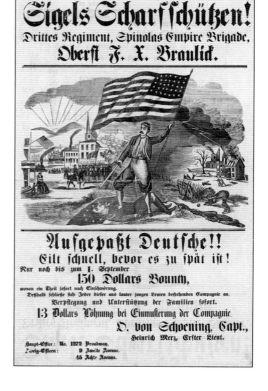

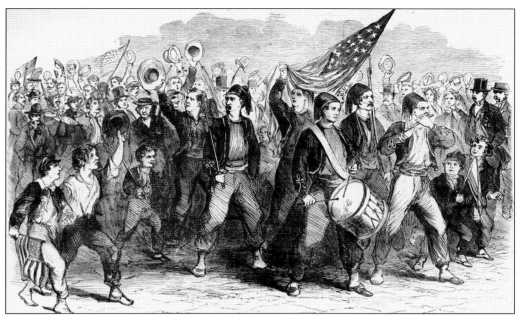

During the spring and summer of 1861, New York City raised two separate forces of US Volunteers: an army of two-year troops recruited by the state and an army of three-year troops recruited by the War Department. Once mustered in, both types of regiments served under federal command. In this illustration, a fife and drum corps belonging to a two-year regiment, Hawkins's Zouaves, marches through the street, encouraging volunteers. (LFFC.)

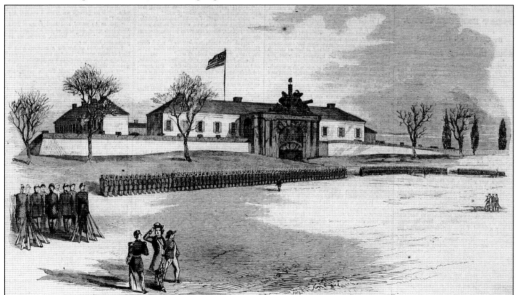

As the city's regiments filled with recruits, the metropolitan government struggled to find places for them to bivouac. Whenever possible, regiments quartered at preexisting military facilities outside of Manhattan. Ideally, removal from the city prevented friends and family from visiting too often. This sketch depicts a regiment—likely a contingent of US Regulars—drilling outside the sally port at Fort Jay on Governors Island in May 1861. (LFFC.)

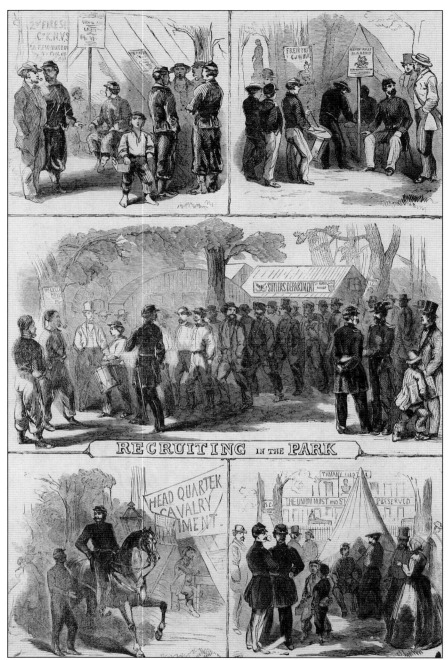

After the defeat at Bull Run, New York City became abuzz with activity; everywhere, recruiters opened stations in office buildings or pitched tents in public parks. Unfortunately, US recruiters struggled to get men to enlist in the three-year regiments. These regiments filled slowly, partly because too many recruiters vied for the finite pool of manpower and partly because, after Bull Run, many New Yorkers lost their martial ardor. Lt. Josiah Favill wrote: "We soon found a great change had come over the spirit of the people since the departure of the militia regiments in April. Then, everybody wanted to go; now, apparently, most people wanted to stay at home." (LFFC.)

At 11:30 p.m. on September 9, 1861, Capt. Roch Crasto of the New York Rifles tried to sneak his company from its encampment at Willet's Point (now Fort Totten Park) to sell his recruits to another regiment. A platoon under Lt. Adolph Georgi (on the right of the illustration) opened fire, killing three of the mutineers. In the aftermath, Brig. Gen. Charles Yates ordered the New York Rifles disbanded. (LFFC.)

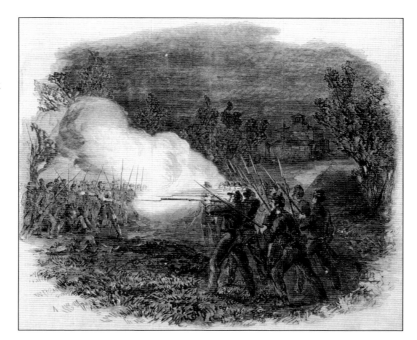

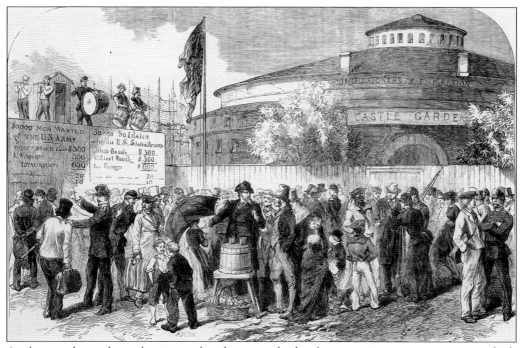

As the war dragged on, the city explored new methods of meeting its manpower quota, which included offering enlistment bonuses called "bounties." Some unscrupulous recruiters endorsed a tactic called "recruit running." This involved scamming newly landed immigrants by convincing them to enlist, while the runners took a cut of their bounty. These runners opened stations adjacent to Castle Garden (shown here), the first immigration depot in US history. (LFFC.)

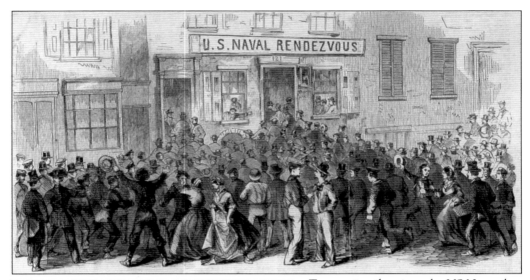

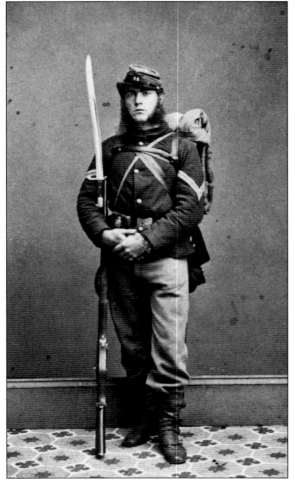

To recruit sailors into the US Navy, the city's criminal element put men under the influence of liquor. Recruiters erected licensed saloons inside buildings that also housed a US naval rendezvous (shown here). One Union officer wrote that, "Out of seven of these naval recruiting rendezvous [in New York City], but three could be entered without first passing through a public drinking saloon of the lowest and vilest character." (LFFC.)

Mobilization of New York City's military forces required a dramatic upsurge in industry to provide each recruit with all his requisite equipment. This photograph depicts a Union infantryman from Company E, 22nd New York National Guard, in full campaign gear: knapsack and blanket roll, cartridge box, belt (with cap pouch and bayonet scabbard), canteen, and Model 1856 Enfield Infantry Short Rifle with sword bayonet. (LOC.)

With textile factories suffering for want of accomplished sewers, working-class women stepped into industrial positions that were typically denied to them. Meanwhile, upper- and middle-class women also produced uniforms for the war, although not on a daily basis. This *Harper's Weekly* illustration by Winslow Homer depicts a women's sewing circle that produced havelocks: cloth kepi covers meant to protect soldiers from the sun. (LFFC.)

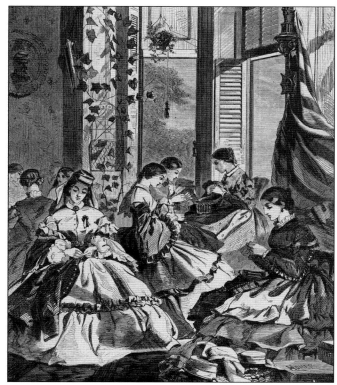

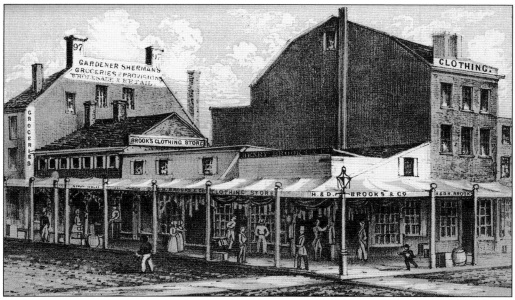

On April 23, 1861, the State Military Board awarded the popular ready-made clothing firm Brooks Brothers a contract to complete 12,000 uniforms for $19.50 apiece. Although the firm initially swore to construct coats and trousers from heavy wool broadcloth, it asked for (and received) an amendment that allowed it to use "shoddy," a thinner fabric made from recycled wool scraps. In a mere 16 days, the firm's factory operatives completed 5,000 uniforms. (GB.)

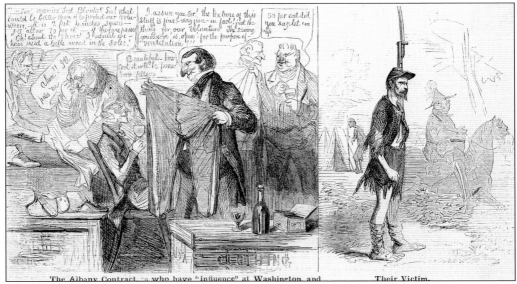

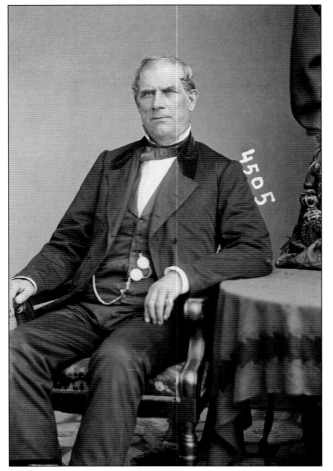

By June 1861, the Brooks Brothers consignment had fallen apart, forcing Union regiments to patrol their encampments in rags. This news caused national uproar, and the State Military Board censured New York's civilian inspectors. Democratic newspapers blamed the Republicans, claiming that Brooks Brothers had bribed the Republican-appointed inspectors. This political cartoon casts the civilian inspectors (left) as the villains, while the threadbare Union soldiers (right) are the victims. (LFFC.)

The "Shoddy Scandal" resulted in a libel case, *Opdyke v. Weed*. Thurlow Weed, an Albany newspaper editor, printed articles accusing George Opdyke (one of the inspectors) of providing the army with faulty blankets. Opdyke sued Weed, requesting $50,000 in damages, but the testimony revealed how Opdyke had taken kickbacks from clothing firms. On January 11, 1865, the jury hung. Most considered it a victory for Weed (pictured here), who paid only minor court fees. (LOC.)

In July 1862, Brig. Gen. Chester A. Arthur took command of the state's depots. A newspaper announced, "It is well known that great inconvenience has been experienced by the commandants of regiments in procuring equipments, &c. on account of the miserable red tape system prevailing in Albany. General Arthur wishes to reform this." Arthur's leadership brought order to the chaos, but he lost his commission in January 1863 when Horatio Seymour took over as governor. (LOC.)

On May 23, 1861, the 1st Regiment, Foreign Rifles, Garibaldi Guard (39th New York Infantry), received its colors at Lafayette Square. The presenter—Phoebe Lloyd Coles Stevens—declared: "I desire to commit to your care this sacred flag—the flag of your country. I know you so consider it, although you were not born under its folds, for you are leaving home and friends to fight against those who have dared to insult it." (LFFC.)

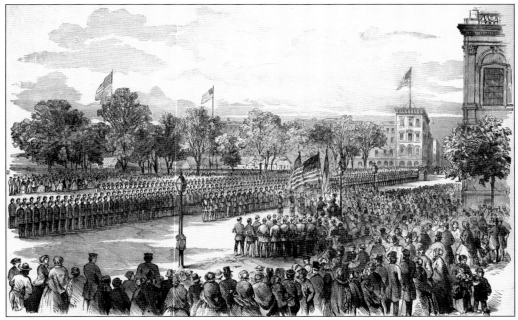

On May 24, 1861, a German-speaking regiment, Col. John E. Bendix's Steuben Guard (7th New York Volunteer Infantry), formed at the Steuben House to receive its colors. Its first flag, a crimson regimental color presented by the "Ladies of the Regiment," contained an image of Baron Friedrich Wilhelm von Steuben wreathed with the words, "Where Liberty Dwells, There is Our Country." Then, at City Hall (pictured here), it received its second flag, a national one. (LFFC.)

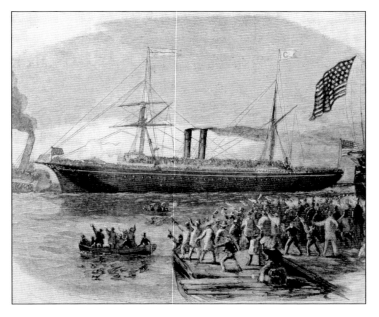

Throughout the war, chaotic departures occurred as completed regiments boarded steamships bound for the seat of war. Friends besieged the soldiers with tearful goodbyes, blessings, and farewells. On June 24, 1861, soldiers in the 31st New York showed up inebriated, and, according to a witness, it became "chaos, come again." This illustration depicts a less-troubled departure, that of the 71st New York State Militia on USS *R.R. Cuyler* on April 21, 1861. (LFFC.)

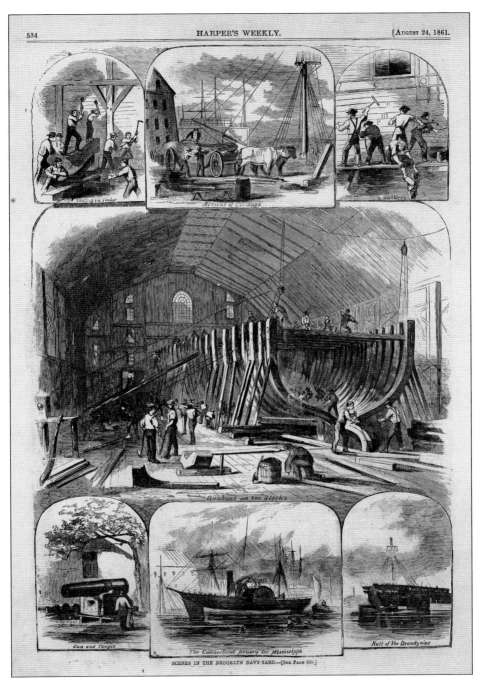

During the war, the Brooklyn Navy Yard employed about 6,000 workers. Their daily tasks involved building and refitting warships and casting cannons and ordnance. This montage depicts yard workers involved in a series of activities. The side-wheeled gunboat at the bottom—USS *Connecticut*—performed admirable service during the war. It assisted in the blockade of Texas, North Carolina, and Virginia. It captured nine enemy vessels, including the blockade runner that carried Confederate spy Belle Boyd. (LFFC.)

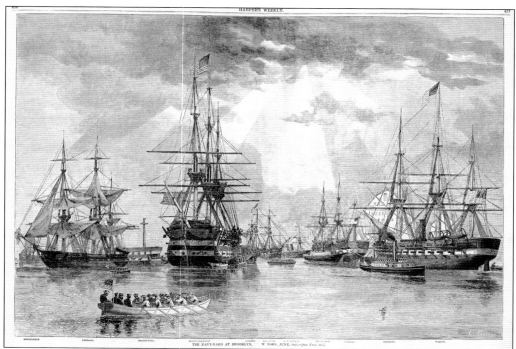

This illustration depicts 11 vessels stationed at the Brooklyn Navy Yard in June 1861. The receiving ship USS *North Carolina* is in the center of the image. At right is USS *Wabash*, a 48-gun screw frigate that served as flagship of the South Atlantic Blockading Squadron. Ahead of USS *Wabash* is USS *Roanoke*, a 43-gun screw frigate. In March 1862, the US Navy converted *Roanoke* into an ironclad monitor, the first to support two rotating turrets. (LFFC.)

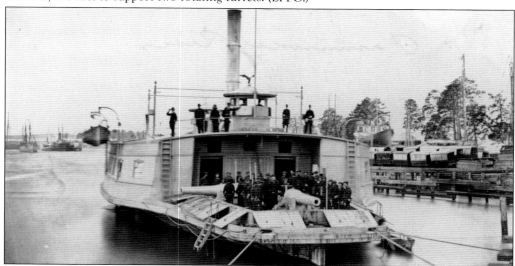

Between September 1861 and August 1863, the US Navy purchased 20 Hudson River ferryboats and converted them into gunboats. This gunboat's identity is uncertain, but it is probably USS *Commodore Morris*, photographed in the Pamunkey River in April 1864. Under optimal conditions, *Commodore Morris* contained a crew of 106 officers and men. At the war's close, the Navy sold this vessel back to the civilian sector. (NHHC.)

In October 1861, Swedish immigrant John Ericsson signed a contract with the US Navy to deliver an ironclad warship. On March 9, 1862, Ericsson's vessel, USS *Monitor*, engaged the Confederate ironclad CSS *Virginia* in the Battle of Hampton Roads, forever changing naval warfare. In 1864, Ericsson purchased a home at 36 Beach Street, a block now known as Ericsson Place. (LOC.)

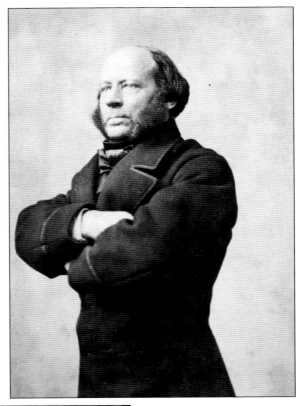

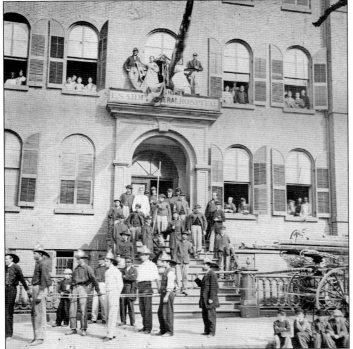

This June 1865 photograph by Jeremiah Gurney and Son depicts the last patients at the US Ladies' Home for Sick and Wounded Soldiers at Lexington Avenue and Fiftieth Street. This hospital opened in May 1862 under the direction of Elizabeth Hall Stryker Opdyke (wife of the mayor), and it treated over 4,000 patients before war's end. US Army chaplain James Tuttle Smith stands on the steps with a cross around his neck, and various nurses peer through the second-story windows. In the foreground, members of Liberty Hook and Ladder Company 16 pose with their engine. (Terry Alphonse, Alphonse Gallery.)

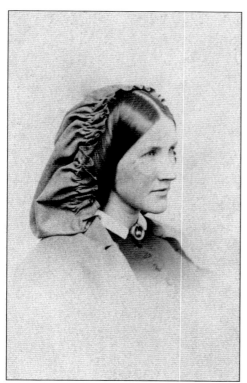

In April 1861, two thousand women gathered at the Cooper Union to establish the Women's Central Relief Association. One of them, Georgeanna Muirson Woolsey, studied nursing and followed the Union army into the field. She served at hospitals in Washington, on hospital ships at Hampton Roads, and at the US Sanitary Commission Lodge at Gettysburg. (University of Arizona Special Collections Library.)

On January 16, 1863, St. Patrick's Cathedral hosted a high requiem mass to honor the sacrifices of the Irish Brigade. By the hundreds, mourners made their way inside, where they beheld a memorial catafalque to symbolize the Irish Brigade's dead. A veteran later reflected that the service produced "a sensation of awe and devotion to which no heart susceptible of the finer emotions of our nature could be indifferent." (LFFC.)

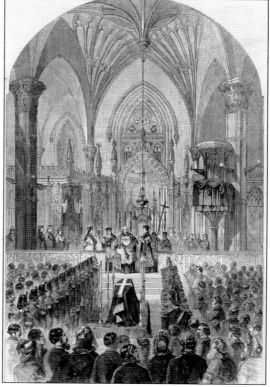

Four

New York City's Boys in Blue

New York City provided the largest number of recruits of any Northern city. Its militia division, the 1st Division, responded four times to the War Department's call-ups, sending 23,868 militiamen on three-month tours of duty. Additionally, New York City answered nine separate calls for US Volunteers, providing 110,132 soldiers to the Union armies. Finally, the state of New York provided 35,164 sailors and marines to the US Navy, the bulk of whom enlisted in New York City.

New York City's soldiers and sailors represented many nations. German Americans filled the ranks of regiments with such stylish names as the Steuben Guard, the United Turner Rifles, the DeKalb Regiment, and the Sigel Rifles. Irish Americans, likewise, sorted themselves into distinctive regiments, such as Kerrigan's Rangers and the Irish Rifles. Meanwhile, Poles joined the Polish Legion, while Franco-Americans joined the D'Epineuil Zouaves or the Lafayette Guard.

Occupation and politics also mattered to New York's soldiers. Firemen wanted to serve alongside other firemen in the Fire Zouaves. Policemen served alongside other policemen in the Metropolitan Brigade. Mariners filled the ranks of the Naval Brigade. Pugilists and street-toughs went into Billy Wilson's Zouaves. The Democratic followers of Fernando Wood joined the Mozart Hall Regiment. Meanwhile, Boss Tweed's faction joined the Tammany Hall Regiment.

Whatever their persuasion, the overwhelming majority of New Yorkers who joined the Union army did so of their own volition, without pressure or compulsion, and stoked by patriotic motives. A member of Hawkins's Zouaves spoke for many when he wrote his mother and sisters that, "I have accordingly entered the ranks—not rashly nor with the spirit of adventure, but with a cool head and under a strong sense of duty. No action of my life has been so well considered and so deliberately taken."

In general, New Yorkers adored their regiments. They routinely corresponded with the local press, they narrated their regiment's happenings, and they composed lusty war songs to honor their achievements. Across a vast continent, New York City's soldiers and sailors hoped that history would forever remember how they helped deliver the death blow to the rebellion.

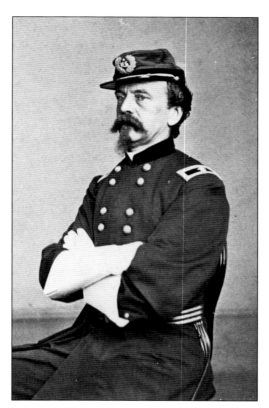

In 1861, controversial Tammany Hall politician Daniel Edgar Sickles raised the Excelsior Brigade, becoming brigadier general in September, major general in November 1862, and corps commander in March 1863. At the Battle of Gettysburg, he received an artillery wound to his right leg, requiring amputation. After the war, he remained active in politics. (LOC.)

In April 1861, stonemason Alexander Shaler went to war with the 7th New York State Militia. Later, he joined the US Volunteers, served all four years of the war, received promotion to brigadier general, and survived six months in Confederate captivity. After the war, he served as major general of the New York State Militia, as New York City fire commissioner, and as mayor of Ridgefield, New Jersey. In 1893, he received the Medal of Honor. (LOC.)

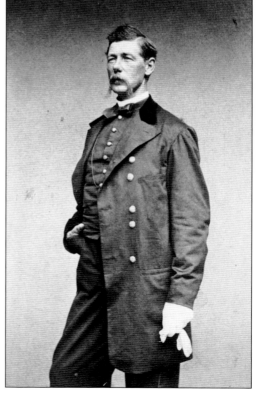

This image depicts a sergeant from Hawkins's Zouaves (9th New York Volunteer Infantry). He is unidentified, but he might be Sgt. Robert B. Johnston of Company H. From its headquarters at 428 Broome Street, the 9th New York filled its ranks in May and June 1861. The regimental motto was *Toujours Prêt* (French for "always ready"). This regiment fought in over a dozen engagements, losing 165 officers and enlisted men as casualties. (LOC.)

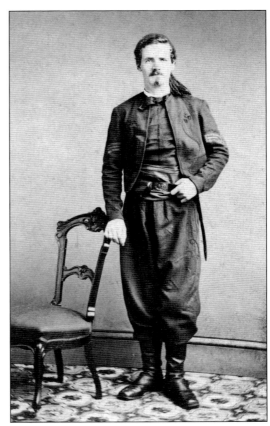

On February 8, 1862, the 9th New York participated in an attack against the Confederate garrison at Roanoke Island. The Zouaves charged a three-gun battery in dramatic fashion (depicted here), losing 17 killed or wounded. Not long after the city press began touting their heroism, newspapers in other states claimed the 9th New York had not been the first regiment to plant its flag atop the enemy works. This dispute continued into the postwar era. (LFFC.)

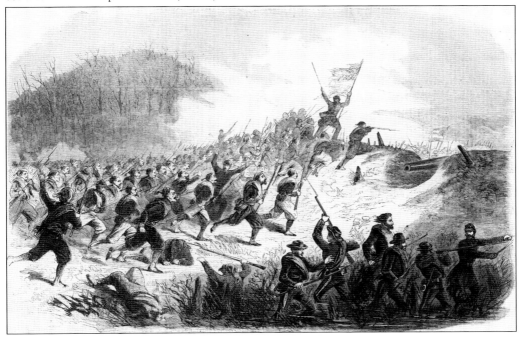

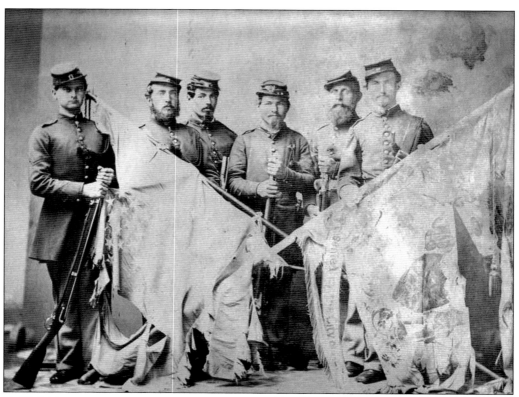

After Fort Sumter, the New York Turner Society appealed to the city's Germans to take up arms. After three weeks of recruiting at Turner Hall on Orchard Street, 700 recruits mustered into service as the 20th New York Volunteer Infantry. Here, at muster out in June 1863, the members of the color guard of the 20th New York are photographed with their tattered banners. (Brian White.)

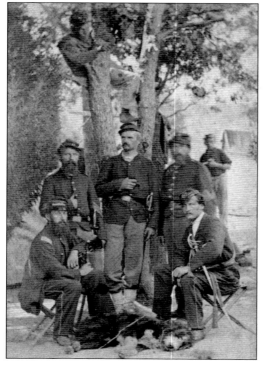

On June 6, 1861, the 1st German Infantry mustered into service as the 29th New York Volunteer Infantry. This image was likely taken in the spring of 1862, when the regiment was encamped in Fairfax County, Virginia. Two officers, 2nd Lt. George Kannig (left) and 1st Lt. Emil Schluter (right), sit on stools, while several enlisted personnel pose behind them. (LOC.)

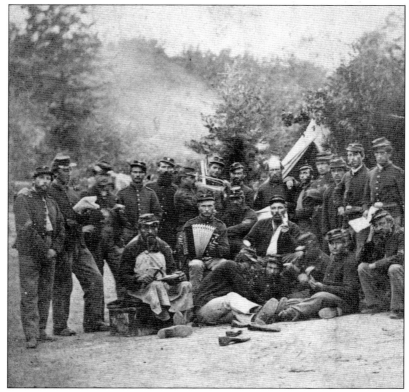

Here, a group of soldiers from the German-speaking 29th New York pose for a photographer, showing off an assortment of leisure activities. One soldier reads a newspaper. Another cobbles his brogans. Another plays an accordion. Another practices his bugle. Four play cards. Several hold letters from home. (LOC.)

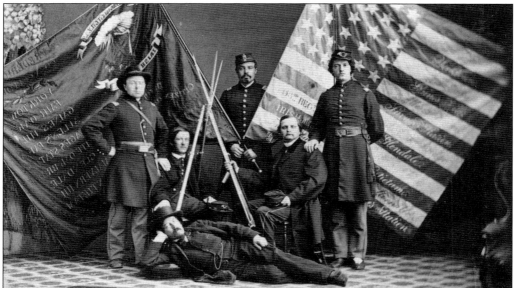

Here, six officers from the 63rd New York—part of Brig. Gen. Thomas F. Meagher's Irish Brigade—pose with their regimental colors: a national emblem (right) emblazoned with battle honors and an emerald-green banner with the Harp of Erin (left). These were replacement banners issued in November 1862. Thirty-four citizens donated funds for their creation and displayed them at the Thomas Hastings News Room in the Museum Building (where this image was taken). (LOC.)

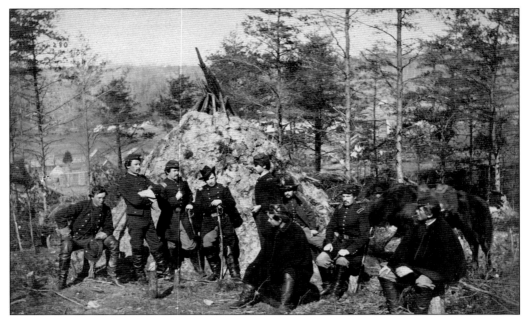

From July to November 1862, Brig. Gen. Michael Corcoran's recruiters filled five regiments that became known as the Irish Legion. This photograph depicts nine Irish Legion officers in their winter encampment. From left to right, the officers are Surgeon Mathew F. Regan, Col. James P. McMahon, Capt. Hugh F. O'Lone, Lt. Col. Michael C. Murphy, 1st Lt. Edward McCaffrey, 2nd Lt. Michael J. Eagan (seated front), unidentified, 2nd Lt. Thomas Montgomery, and unidentified. (LOC.)

Here, soldiers from Company I, 170th New York, pose near their winter quarters in Virginia, the same location as the previous photograph. The mounted officer is Lt. Col. Michael Cotter Murphy, who was born in Limerick, Ireland, in 1841. He served as a captain in Ellsworth's Zouaves before commissioning as a field officer in the 170th New York. After the war, Murphy served as a seven-term state assemblyman and a six-term state senator. In 1897, he received the Medal of Honor. (LOC.)

In August 1861, Col. Lionel J. D'Epineuil began raising a regiment of Franco-Americans, the D'Epineuil Zouaves (53rd New York Volunteer Infantry). This is D'Epineuil's second-in-command, Lt. Col. Joseph Antoine Vignier de Monteil, a mathematics teacher from Toulon who had been a political prisoner during the 1848 Revolution. On February 8, 1862, he was killed leading the attack against the Confederate earthworks on Roanoke Island. (LOC.)

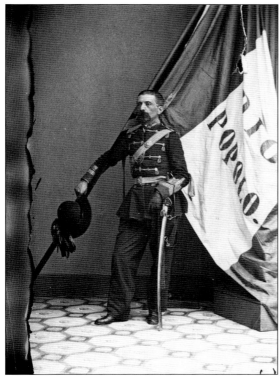

Here, Lt. Col. Alexander Repetti—a veteran of the Italian War for Independence—poses with one of the 39th New York's flags, an Italian tricolor with the phrase *Dio E Popolo* ("God and the People"). After Repetti threatened to shoot a sick soldier, he faced a court-martial. Testimony revealed that, while hiding from combat, he vowed never to give his life for such a "stupid country." After this, Repetti resigned from the army. (Medford Historical Society.)

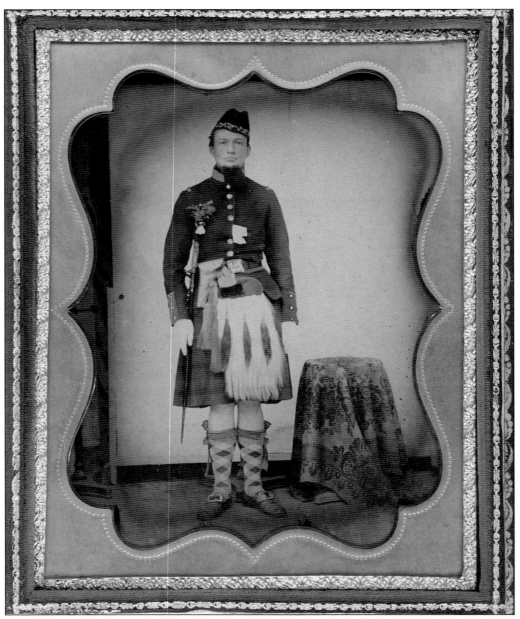

Mustered into service on May 29, 1861, Cameron's Highlanders (79th New York Volunteers) recruited among the city's Scottish American population. During dress parade, the Highlanders wore traditional Scottish regalia (shown here): plaid kilt, tartan hose, sporran, and glengarry cap. On campaign, they wore more practical attire: plaid trousers, shell jackets, and kepis. The 79th New York earned notoriety when it mutinied after the Battle of Bull Run, refusing to obey the orders of its commander. But it soon redeemed itself, fighting proudly during the invasion of James Island, South Carolina. By the end of the war, it had participated in 37 battles or skirmishes, sustaining a loss of 558 officers and enlisted men killed, wounded, or captured. This member of the 79th New York is unidentified. (LOC.)

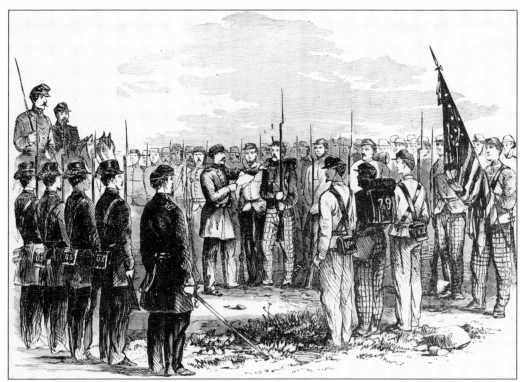

After Bull Run, nine dissatisfied officers in the 79th New York resigned their commissions. Believing their officers had betrayed them, the enlisted men demanded an opportunity to return to the city and reorganize. Instead, the War Department appointed a new commander, which induced the Highlanders to mutiny. On August 14, 1861, under Maj. Gen. George McClellan's orders, another regiment arrested 21 ringleaders and seized the regiment's battle flag (illustrated here). (LFFC.)

During the war, the city raised 16 cavalry regiments and two regiments of mounted rifles. This photograph depicts one of them: the 13th New York Cavalry. Fully mounted, the regiment is photographed in 1864 undergoing inspection near Prospect Hill, Virginia. Raised in the summer of 1863, this regiment participated in over 30 skirmishes, losing 31 troopers killed or mortally wounded. (LOC.)

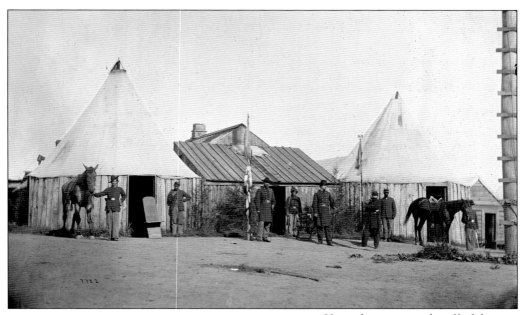

Here, the regimental staff of the 13th New York Cavalry stand outside their headquarters at Prospect Hill. Col. Henry S. Gansevoort stands between the two flags, hand atop the hilt of his saber. When recruiting his regiment, Gansevoort promised it he would refrain from drink. One of his advertisements read: "A drunken Commander is a deadlier enemy to his men than a whole rebel division. Boys, Enlist Only with Sober Men!" (LOC.)

In 1861, James Gordon Bennett Jr., son of the editor of the *New York Herald*, was commissioned as a third lieutenant in the US Revenue Cutter Service and he volunteered his transatlantic schooner-yacht Henrietta for federal service. In March 1862, he participated in the capture of Fernandina, Florida. In December 1866, Bennett participated in a high-profile boat race across the Atlantic, winning a prize of $30,000. He remained a newspaperman and celebrity up until his death in 1918. (LOC.)

Because the US Navy promised prize money to each crew that captured a Confederate ship, naval service tended to appeal to men down on their luck. Thus, naval recruiting drives in the city often did well. According to the records of the County Volunteer Committee, between April 12, 1861, and April 4, 1864, New York City recruited 25,451 men into naval service. Here, an enlisted sailor from the city has his image struck. (LOC.)

This image depicts an inspection for a regiment belonging to the Excelsior Brigade—quite likely Col. William Dwight Jr.'s 70th New York Volunteer Infantry. From the autumn of 1861 to the spring of 1862, the Excelsior Brigade bivouacked at Camp Farnum, Liverpool Point, Maryland, on the lower Potomac. This image was likely taken at that location. (LOC.)

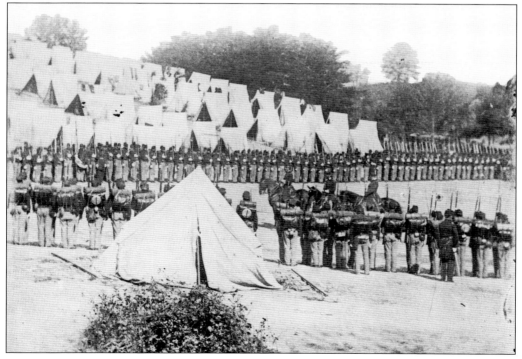

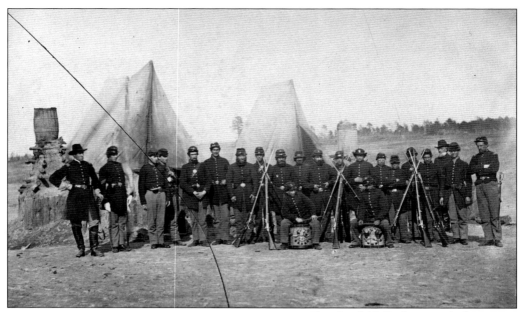

This April 1863 photograph depicts a depleted company at its winter quarters in Falmouth, Virginia. In October 1861, this unit—Company H, 61st New York Volunteer Infantry—left with 85 officers and enlisted men. In a year and a half, it lost 75 percent. Capt. Nathan C. Bull stands at left. First Lt. Lee Nutting stands at right. Chaplain Henry D. Burdock stands third from the right. Musicians Philip Hertz and James Moran sit on their drums. (LOC.)

Officially, no one under 18 years of age could enlist without their guardian's consent, but many underage soldiers joined despite this restriction. This photograph depicts one of New York City's youngest soldiers, drummer Julius Caesar Machler, who enlisted in Company H, 103rd New York Volunteer Infantry, at the age of 13. Machler lied about his age, claiming to be 19. He served for four years, mustering out at City Point, Virginia, on December 7, 1865. (LOC.)

On June 15, 1861, the War Department authorized Hiram Berdan to raise two regiments of riflemen, the 1st and 2nd US Sharpshooters. Berdan established his rendezvous at Weehawken, New Jersey, on the west side of the Hudson River. This US Sharpshooter, who had his photograph struck by Broadway photographer Nathaniel Jaquith, wears a dark green frock coat and carries a privately purchased target rifle fitted with a telescopic sight. (LOC.)

On July 21, 1861, Thomas Storms enlisted in the 74th New York, and he went on to participate in over 20 engagements. On December 31, 1863, he reenlisted as a "veteran volunteer," intending to stay on three additional years. On June 17, 1864, he was wounded at the Battle of Petersburg. Here, he wears a Veteran Reserve Corps uniform with a veteran service stripe. Storms returned to the front, joining the 40th New York before mustering out on June 27, 1865. (LOC.)

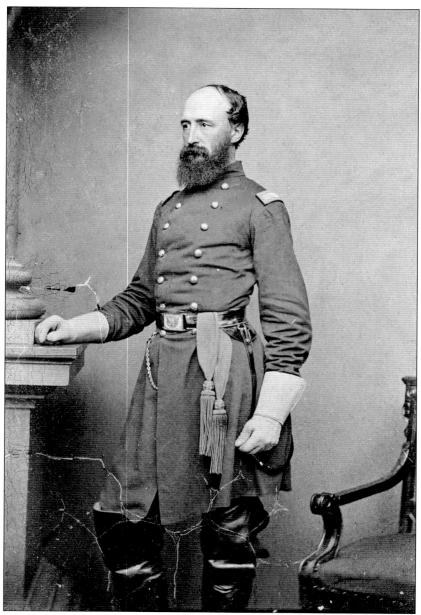

On May 31, 1862, while leading the 62nd New York Infantry in the Battle of Fair Oaks, 30-year-old Col. John Lafayette Riker, a city attorney and single parent, was killed in action. Back in the city, a meeting of associates from the city bar resolved that "in his courage as an American soldier, in services to his country as an officer, in his proved patriotism upon the field of battle, and in his noble example both to do and to die for his country, we find grateful evidence that our friend was worthy the confidence and respect reposed in him by his fellow-citizens." On June 10, 1862, for four hours, Riker's body would lie in state in the Governor's Room at City Hall to allow well-wishers to say their grief-stricken farewells. Then, a massive procession involving 300 policemen and thousands of militia conveyed his body via hearse along Chatham Street, then the Bowery, then Bond Street, then Broadway, and then to South Ferry for its trip to Green-Wood Cemetery. (NPG.)

Five

STREET SCENES AND SOCIAL LIFE

With a population north of 800,000 in 1860, New York City dwarfed all other urban areas in the nation. (Brooklyn, which would become part of New York City in 1898, was the third-largest city in the United States with more than 270,000 residents.) Culture, art, fashion, literature, and political journalism emanated from the city to the rest of the nation, and the streets of Lower Manhattan boasted more theaters, shops, factories, and hotels than any other city in the United States.

Mary Lincoln famously spent thousands of dollars on shopping sprees in Manhattan, purchasing extravagant clothing and furnishings for the White House. When her husband found out, he said her overspending "would stink in the nostrils of the American people to have it said that the President of the United States had approved a bill overrunning an appropriation of $20,000 for flub dubs for this damned old house, when the poor freezing soldiers cannot have blankets!" When abolitionist Lydia Maria Child learned of Mary Lincoln's shopping excesses, she remarked disdainfully: "So this is what the people are taxed for! To deck out this vulgar doll with foreign frippery."

In the 1860s, most of Manhattan's residential, commercial, and manufacturing districts were south of Forty-Second Street. One historian wrote, "So sparce was the population" farther north "that the city allowed the production and storage of explosives in factories north of 62nd Street during the war."

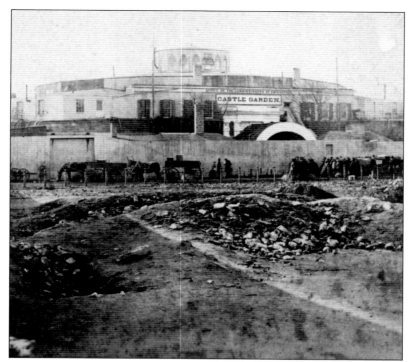

Built between 1808 and 1811 on the southern tip of Manhattan, Castle Garden operated as an immigration station from 1855 to 1890. When Brig. Gen. Michael Corcoran was scheduled to arrive at Castle Garden on August 22, 1862, after his long captivity as a prisoner of war in the Confederacy, thousands of people crammed onto Broadway to greet him, while nearby cannons boomed. (LOC.)

As the commercial hub of the United States, Manhattan boasted many companies that remain prominent to this day, including the clothier Brooks Brothers, the piano manufacturer Steinway and Sons, the jeweler Tiffany's, and the department stores Bloomingdale's and Macy's. This image shows the interior of a photographic shop occupied by Paul & Curtis at 594 Broadway. (LOC.)

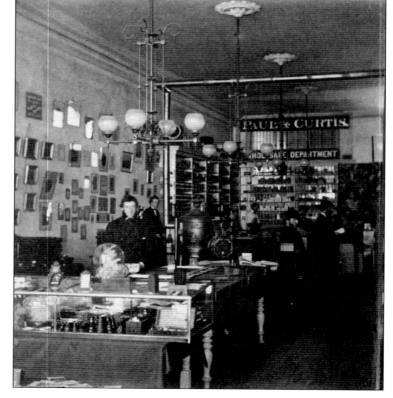

Established in 1859, the National Bank Note Company was one of several private companies to print "greenbacks" for the federal government during the war. Taken from Broadway (near Trinity Church), this image shows the National Bank Note Company (the white building with awnings at the far right), which was located at 1 Wall Street, and the Bank of the Republic, which was located at 2 Wall Street. (LOC.)

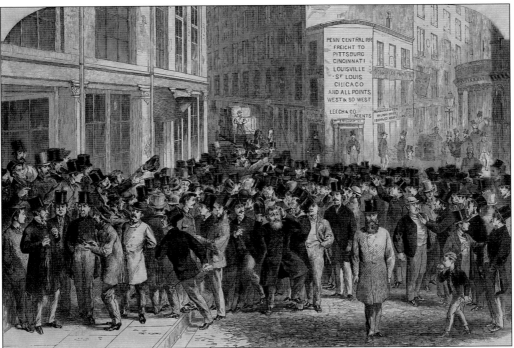

In this 1864 image, which looks south on William Street from Exchange Place, a group gathers outside the public stock exchange in "a frantic orgie, in which the lust of lucre reigns supreme." The *Illustrated London News* reported that this "Kerbstone" business was "the common whirlpool of all persons of speculative tendencies who have not sufficient capital or character to obtain admission" into the "recognised" stock exchanges. (LFFC.)

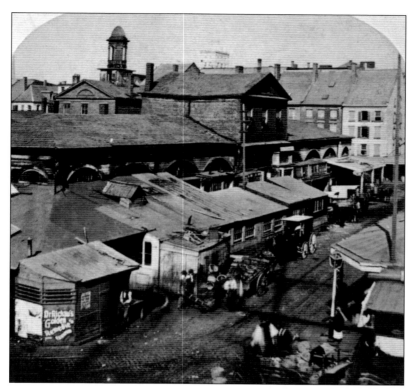

From 1822 until 2005, the Fulton Market was a major fish market in Lower Manhattan, located above Fulton Street near the East River. Fish were unloaded daily from ships at the city docks. According to one 19th-century writer, 90 percent of the fish sold in New York City passed through Fulton Market. In 2005, the market relocated to the Hunts Point Cooperative Market in the Bronx. (NYPL.)

Street construction is a perennial frustration for residents of big cities. In April 1860, the *New York Times* reported that "the return of pleasant weather" led to the "repairing and repaving [of] the pavements of the City." The workforce consisted of 17 "gangs," each of which had 13 men and one foreman. The laborers received $1.50 per day, the foremen $2, and the dirt cartmen $2.50 each. (NYPL.)

Located near the intersection of Park Row, Worth Street, and Baxter Street, Five Points was an immigrant neighborhood rife with crime, prostitution, gang violence, drunkenness, and debauchery. In 1851, reformers established the Five Points House of Industry to prepare young people for better employment opportunities. In March 1860, following his Cooper Union address, Abraham Lincoln visited the House of Industry. Lincoln told the children, "I had been poor; that I remembered when my toes stuck out through my broken shoes in the winter; when my arms were out at the elbows; when I shivered with the cold." But he encouraged them with one rule of life: "Always do the very best you can." If they followed this rule, he said, "they would get along somehow." (Above, LOC; below, NYHS.)

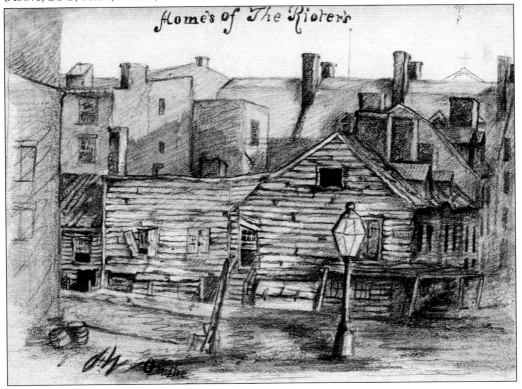

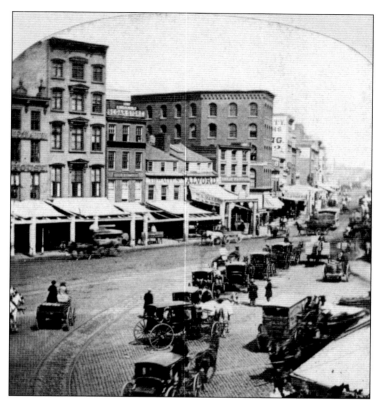

Located just east of Five Points, Chatham Square was a busy commercial and residential center in Lower Manhattan. At 3:00 a.m. on Monday, May 2, 1864, a devastating fire tore through 210 Chatham Square, on the corner of Doyers Street, causing damage and killing a family of five, including a German immigrant who "sprang from the window" of his third-story apartment and plunged to the sidewalk below, according to the *New York Herald*. (LOC.)

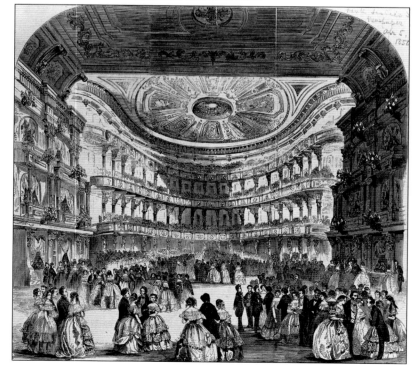

On February 20, 1861, Abraham and Mary Lincoln saw Giuseppe Verdi's *A Masked Ball* at the Academy of Music. The opera is based loosely on the 1792 assassination of Swedish king Gustav III. When the president-elect was observed wearing black gloves, one Southerner in the audience groused, "I think we ought to send some flowers over the way to the Undertaker of the Union." (NYPL.)

Going to the theater was a favorite pastime for residents of New York City during the Civil War. The Olympic Theatre opened at its third location, 662 Broadway, near Houston Street, in 1856. Known as Laura Keene's Theatre until that famous actress left in 1863, this building remained open as the Olympic Theatre until it was demolished in 1880. The exterior image shows a busy scene on Broadway outside the building, while the image below captures a scene from an 1864 production of Charles Dickens's *Martin Chuzzlewit*. (Right, LOC; below, JW.)

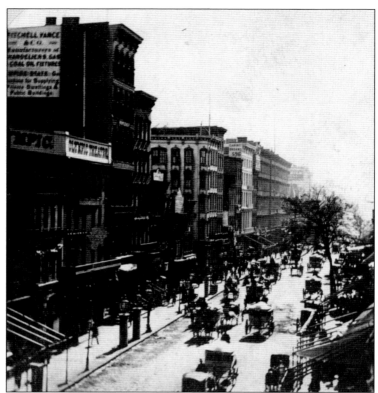

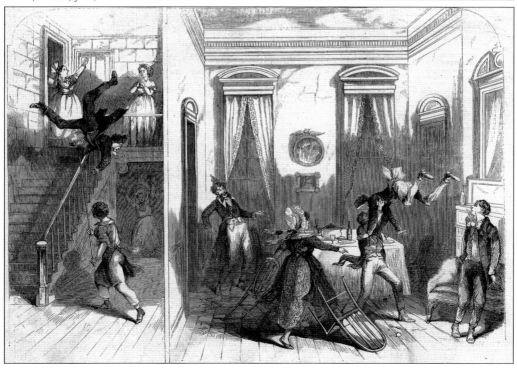

Henrietta Irving played stages across America, including Wallack's Theater in New York City. In the spring of 1861, she was starring in a production of *Evadne* alongside the famous Shakespearean actor John Wilkes Booth. Following a performance in Albany on April 26, Irving and Booth went back to his hotel room, where they drank heavily. However, when he did not reciprocate her "affections," she attempted to stab him in the heart. Under the headline "All for Love and Murder," one newspaper reported that she "attacked him with a dirk, cutting his face badly." After that, she "retired to her own room and stabbed herself, not bad enough to 'go dead,' however." Neither wound proved mortal, and both actors went their separate ways. Of course, Booth survived long enough to change the course of history. This photograph is by Jeremiah Gurney and Son on Broadway. (JW.)

Museum owner and sensationalist promoter Phineas T. Barnum's (1810–1891) name is synonymous with showmanship. Barnum's American Museum, which opened at the corner of Broadway and Ann Street in 1841, featured innumerable hoaxes, curiosities, and freaks. In November 1864, Confederate operatives attempted to destroy the building using a combustible chemical known as "Greek fire." After two devastating fires in 1865 and 1868, Barnum turned to the traveling circus business. (LOC.)

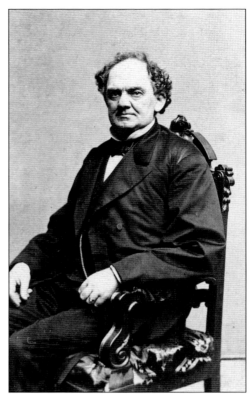

When Confederate privateers captured the *S.J. Waring* on the Atlantic Ocean in July 1861, they found a 27-year-old steward named William Tillman on board. When Tillman realized they planned to sell him into slavery in Charleston, he killed them with a hatchet and sailed the ship northward. Once in Manhattan, he became a celebrity, greeting streams of visitors at US Marshal Robert Murray's office and Barnum's American Museum. (NHHC.)

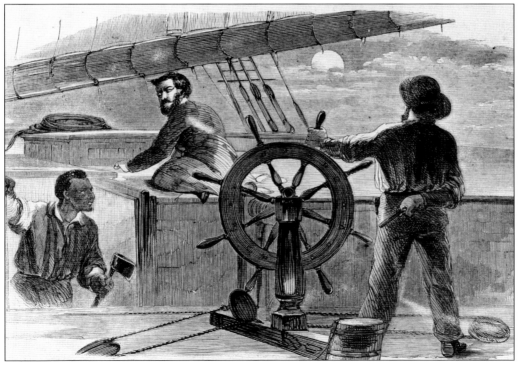

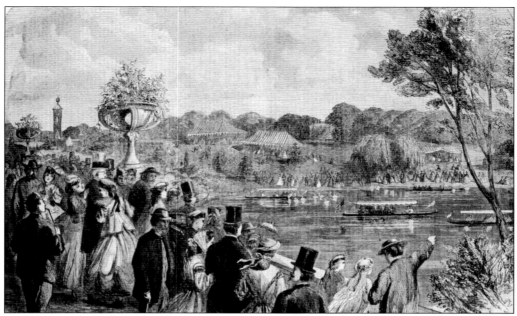

Throughout the war, citizens of New York gathered in Central Park to enjoy live music. Following one concert by Dodworth's Band in 1865, the *New York Herald* reported that a "very respectable audience" gathered beneath the trees by the lake. The musicians were "rowed slowly around the lake" in a large boat, "and the sweet strains of their wind instruments gave unqualified pleasure to all present." (LFFC.)

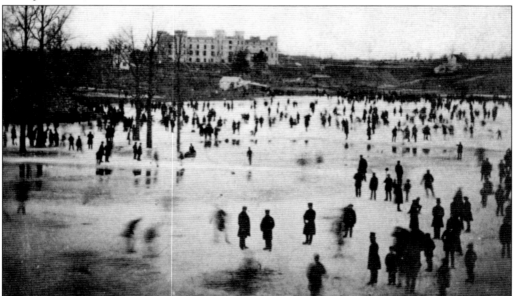

In the winter, New Yorkers enjoyed ice skating in Central Park. The *New York Herald* reported that a "heavy fall of snow" on Monday, January 6, 1862, led many to believe that "skating would not be allowed in the Park." Nevertheless, "the ponds were cleared of snow," and 6,000 people came out to skate on Tuesday. This was far fewer than would normally have appeared, reported the *Herald*. (LOC.)

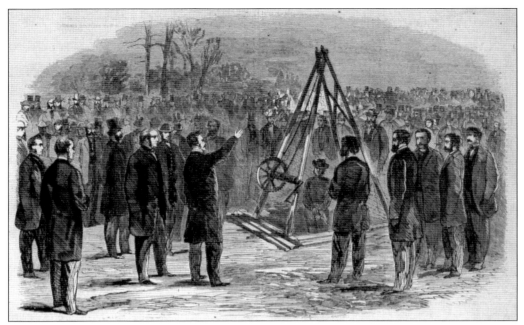

In 1864, several city leaders, including actor Edwin Booth, petitioned the Central Park commissioners "on behalf of the actors and theatrical managers" of the city to erect a monument to William Shakespeare. The cornerstone was laid in April 1864 (shown here from *Harper's Weekly*), the 300th anniversary of the Bard's birth, although the monument—which was sculpted by John Quincy Adams Ward—was not dedicated until 1872. (LFFC.)

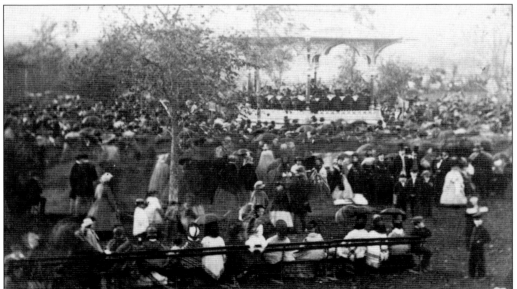

This c. 1865 photograph by George Stacy, titled "Saturday Afternoon," shows a large gathering of people near Central Park's Music Pavilion. On Sunday, June 4, 1865, the *New York Times* reported on one concert where "the ladies came out in full force" and "strolled about gazing at each other and criticizing the costumes" of the other women. The *Times* estimated that nearly 20,000 people visited Central Park that day. (LOC.)

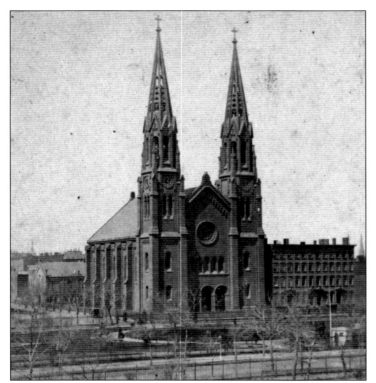

At St. George's Church on Stuyvesant Square, Rev. Stephen H. Tyng (1800–1885) preached pro-Union sermons, including one in 1863 in which he rejoiced that slavery had "at last . . . received its inevitable destruction." Built between 1846 and 1856, St. George's was severely damaged by a fire in November 1865. Though the church is still standing, its spires were removed in 1889. (LOC.)

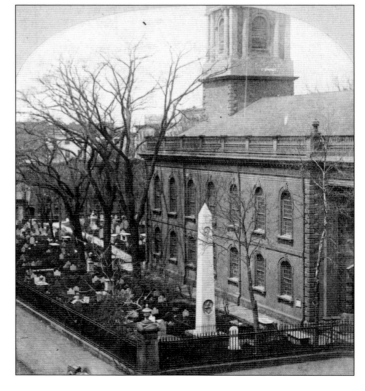

Constructed in 1766, St. Paul's Chapel at Trinity Church on Broadway is the oldest church in Manhattan. In April 1861, according to the *New York Herald*, the church's trustees "evinced a very patriotic spirit" by authorizing US flags to be hung from the spires. Upwards of 50 young men attempted to hang a flag from the cross atop Trinity's spire before one of them, Thomas Davidson, finally accomplished the dangerous feat. (LOC)

Known as "Dagger John," Archbishop John Hughes was a virulent fighter for the rights of Roman Catholics and immigrants. An opponent of abolitionism, Hughes faced death threats from Protestant mobs in the years before the Civil War. During the draft riots in July 1863, he addressed a crowd from the balcony at his home, strangely telling them, "I cannot see a riotous face among you." (LOC.)

In January 1864, the "old" St. Patrick's Cathedral held a solemn funeral for Archbishop Hughes, whose remains were interred in one of the cathedral's vaults. For several days before the funeral, his body was placed in the middle aisle in front of the grand altar, where it would lie in state so that the community would "have an opportunity of viewing the corpse of the illustrious prelate," per the *New York Herald* (LOC.)

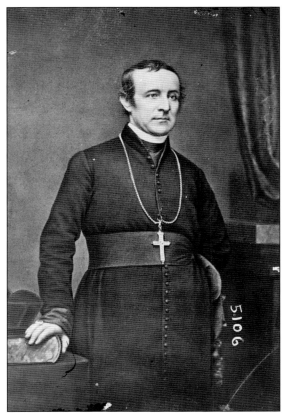

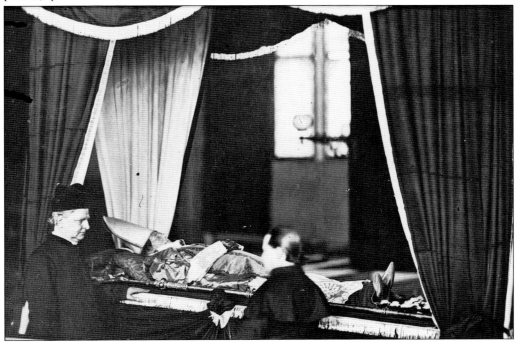

Located on a block bounded by Fifth Avenue, Madison Avenue, and Fiftieth and Fifty-First Streets, construction of the "new" St. Patrick's Cathedral began in 1858 but was delayed by the Civil War. It was not dedicated until 1879. On January 3, 1882—the 18th anniversary of his death—Archbishop Hughes was reinterred in a crypt at the foot of the altar. William T. Sherman's initial funeral mass would take place here in 1891 before his body was transported to St. Louis, Missouri. When Daniel Sickles died in 1914, his funeral also took place at St. Patrick's. A reporter for the *New York Sun* wrote, "Fifth Avenue was crowded all the way and thousands bared their heads as the body passed. Flags on all the buildings were at half mast and many were draped with crape. . . . Every window was full of heads, including the clubs, many of whose members also went to the church service." (LOC.)

Six

Politics and Politicians

New York City was the center of national politics in the mid-19th century. The most influential newspapers in the nation—the *Tribune*, the *Times*, and the *Evening Post* for the Republicans; the *World*, the *Journal of Commerce*, and the *Daily News* for the Democrats—were just six of the dozens of newspapers published in the city. Articles from these papers would radiate throughout the nation as they were picked up and copied in smaller papers in towns, cities, and counties throughout both the North and South.

While the city had a bipartisan national influence, its local politics was overwhelmingly Democratic. Supported by Irish Catholic immigrants, conservative elites, and working-class poor, the Democratic Party outnumbered the reform-minded Republican Party by massive numbers. When the Democrats remained united, they dominated city politics. And their lavish spending of public funds and uninhibited corruption lined the pockets of their party leaders. However, factionalism in the Democratic machine Tammany Hall and Mayor Fernando Wood's arrest following the Police Riot of 1857 led Wood to create a rival Democratic machine, Mozart Hall, which was named after the hotel at 663 Broadway where they met. This division among the Democrats enabled Republican George Opdyke to win the mayoral race in 1861. It would not be until the midpoint of the war that a strong Democratic leader, William M. "Boss" Tweed, would emerge to unite the Democrats and set them on the path of unified political domination of the city for many years to come.

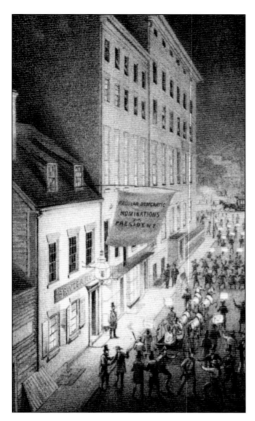

Led by men such as Fernando Wood and Daniel Sickles in the years before the Civil War, Tammany Hall was a powerful Democratic machine in New York City whose leaders were known as sachems (chiefs). From 1812 to 1868, Tammany Hall met in this five-story building, which was located at the corner of Nassau and Frankfort Streets (it was razed to make way for the Brooklyn Bridge). (GB.)

Isaac V. Fowler (1818–1869) was an unusual grand sachem of Tammany Hall because he had been educated at Columbia College. In 1860, he was indicted for embezzling more than $155,000, but the US marshal (a Democrat) "tarried at the bar" at the New York Hotel where Fowler was living, allowing him to escape to Mexico, where he remained until the charges against him were dropped after the Civil War. (LOC.)

Benjamin Wood (1820–1900), Fernando's younger brother, edited the anti-Lincoln *New York Daily News*, the official organ of Mozart Hall, the Democratic machine that broke away from Tammany. As a member of Congress in 1861, Wood was suspected of treason for using his paper to convey Union secrets and personal messages to the Confederates through classified advertisements. The House Judiciary Committee investigated the case, but the matter was eventually dropped. (JW.)

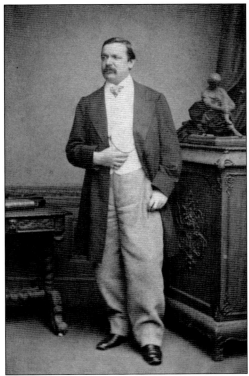

Samuel L.M. Barlow (1826–1889) was one of the most powerful businessmen and lawyers in the city, with a beautiful home on the corner of Twenty-Third Street and Madison Avenue. "His success in making money was enormous," wrote one biographer, and he once collected a $25,000 fee for a half-hour's work! Barlow was part-owner of the *New York World* and was influential with Democratic leaders around the country. (The Huntington Library.)

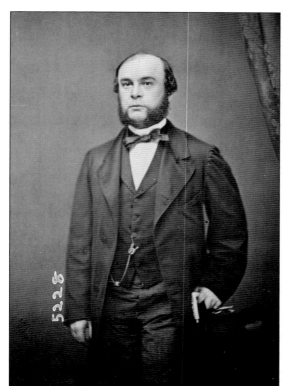

August Belmont (1813–1890) immigrated to the United States from Alzey (now in Germany) in 1837 and settled in New York City, where he became extraordinarily wealthy. He was part-owner of the *New York World* and chairman of the Democratic National Committee from 1860 to 1872. In 1862, Belmont warned Barlow not to associate with certain Peace Democrats because they "are disloyal & unreservedly express their sympathy with the Rebels." (LOC.)

When Manton Marble (1835–1917) became editor of the *New York World* in 1862, he transformed the floundering paper into an important Democratic organ. In 1864, Marble blamed Lincoln for "four years of usurpation" and "lawless, reckless, mis-government." Wall Street lawyer George Templeton Strong likened Marble to "vermin," and "a mercenary renegade" who, along with the city's other leading Copperheads, deserved "the cincture of a legal halter" around "their traitorous necks." (JW.)

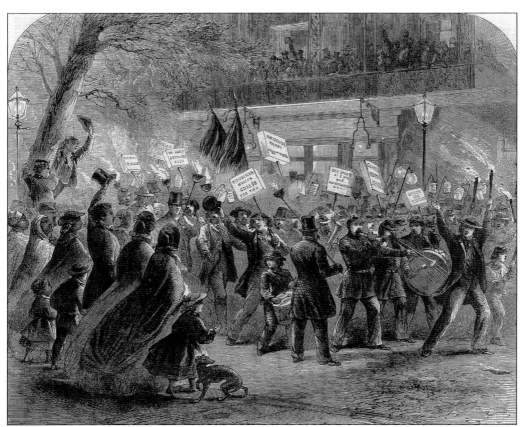

As war weariness swept through the nation in 1862, Democrats celebrated the election of Horatio Seymour as governor with this parade that went past the New York Hotel on Broadway. When George Templeton Strong observed a "dirty" Democratic procession right before the election, he wrote in his diary that he "felt as if a Southern Army had got into New York." (JW.)

Scottish immigrant James Gordon Bennett (1795–1872) founded the *New York Herald* in a Wall Street basement in 1835. From these humble beginnings, he established a journalistic empire that transformed the newspaper industry, offering readers sensational accounts of murder, prostitution, and other aspects of city life. Bennett attacked politicians of all stripes, calling Lincoln "a vulgar village politician." Detractors dubbed Bennett an "ill-looking, squinting man," and "His Satanic Majesty." (LOC.)

Arguably the most important editor of the mid-19th century, Horace Greeley (1811–1872) pressed the Lincoln administration on many matters during the war. In July 1861, his *New-York Tribune* trumpeted, "Forward to Richmond." In 1862, Lincoln publicly called Greeley "an old friend, whose heart I have always supposed to be right," but in private, Lincoln likened him to an "old shoe—good for nothing now, whatever he has been." (LOC.)

In 1858, the *New York Times* moved from 138 Nassau Street, near City Hall, to 41 Park Row in a building that had been constructed specifically for the *Times*. This image, which was taken from Tryon Row, shows the *Times* building on Park Row, just east of City Hall Park, which is to the right. St. Paul's Chapel of Trinity Church is in the distance. (NYPL.)

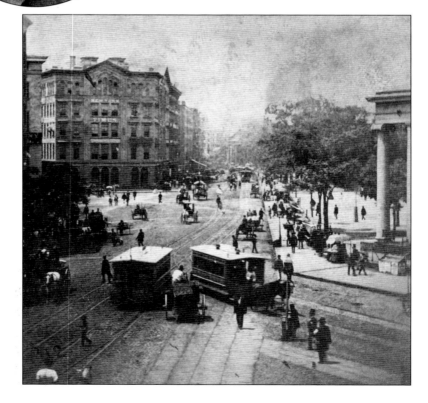

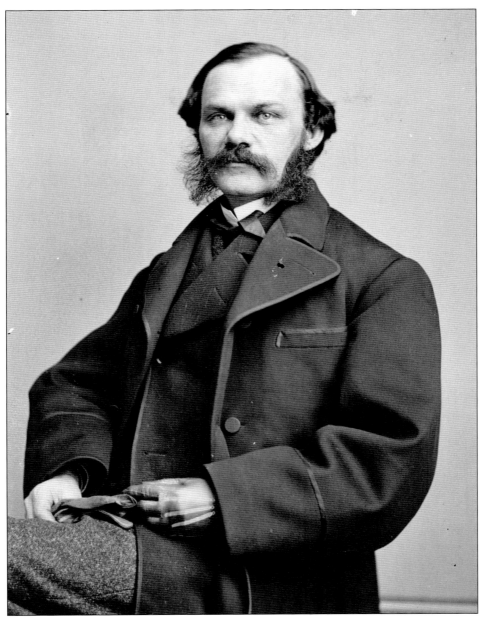

A poor child prodigy from Lima, New York, Henry J. Raymond (1820–1869) became an admirer of Horace Greeley's during his teenage years and, after Greeley established the *New-York Tribune*, worked as an editorial assistant for the *Tribune* in the 1840s. In 1851, Raymond became founding editor of the *New York Times*, and in the mid-1850s, he helped found the Republican Party. (The party was established in response to Sen. Stephen A. Douglas's Kansas-Nebraska Act in 1854, which sought to open federal territories to slavery. It ran its first presidential candidate, John C. Fremont, in 1856.) In 1864, Raymond was selected as the national party chairman during Lincoln's bid for reelection, and he wrote the party's national platform that year. Following the election, the famous orator Edward Everett wrote to Raymond on December 9, "Warmly congratulating you on the result of the election, what you have done so much to promote." (LOC.)

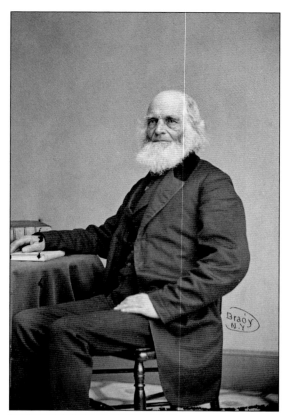

William Cullen Bryant (1794–1878) was the longtime editor of the *New York Evening Post* and a poet of great renown in the 19th century. Politically active in New York, Bryant wrote to Lincoln nearly 80 times between 1860 and 1865, frequently recommending patronage appointments to the president. A statue of Bryant stands prominently in Bryant Park, behind the New York Public Library's Stephen A. Schwarzman Building in Midtown Manhattan. (NPG.)

As many as 125 newspapers were suppressed by mobs, soldiers, or the Lincoln administration during the war. Shortly after Peace Democrat Clement L. Vallandigham of Ohio was arrested for disloyal speech, *Vanity Fair* ran this cartoon, "The Hand-Writing on the Wall," in June 1863, depicting "the weak-kneed editors of New-York" afraid to speak out against Lincoln for fear that they would wind up as prisoners in Fort Lafayette. (GB.)

In May 1864, two Democratic papers in New York, the *World* and the *Journal of Commerce*, were duped by journalist Joseph Howard Jr. (pictured here) into publishing a bogus proclamation calling for 400,000 volunteers. Infuriated, Lincoln personally ordered the arrest of the papers' editors, Manton Marble and William C. Prime. Marble later likened Lincoln to King Charles I, who similarly perpetrated "crimes by which he lost his crown and his life." (LFFC.)

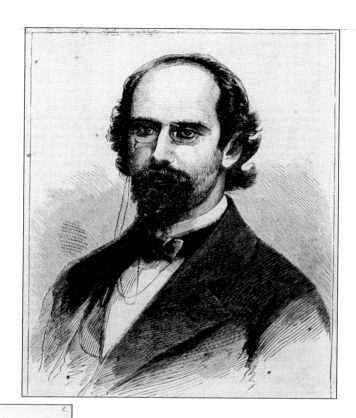

One night over a steak dinner at Delmonico's in 1863, Democratic leaders founded the Society for the Diffusion of Political Knowledge, to be led by inventor Samuel F.B. Morse. The society published dozens of pamphlets, branding abolitionists as "the dark conclave of conspirators, freedom-shriekers, Bible-spurners, fierce, implacable, headstrong, denunciatory Constitution-and-Union haters, noisy, factious, breathing forth threatenings and slaughter against all who venture a difference of opinion from theirs." (JW.)

As early as 1862, Republicans throughout the North began establishing Union League clubs to show support for the war effort and to assist Republican candidates for office. The Union League of New York opened its first clubhouse across the street from Union Square at 26 East Seventeenth Street on May 12, 1863. Still in existence today, the Union League's current clubhouse is located at 38 East Thirty-Seventh Street. (NYPL.)

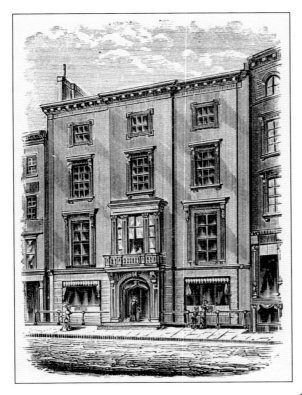

Presbyterian minister Henry Highland Garnet (1815–1882) escaped from slavery in Maryland as a child and settled in New York, where he gained an education and became a prominent minister and abolitionist. After escaping the violence of the New York City draft riots in 1863, Garnet moved to the nation's capital, where he served as minister of the Fifteenth Street Presbyterian Church. (NPG.)

James McCune Smith (1813–1865) was born into slavery in New York City, becoming free under the state's emancipation act in 1827. Smith became the first African American to earn a medical degree (at the University of Glasgow, Scotland, in 1837) and for nearly two decades was the physician at the Colored Orphan Asylum in New York City—a building tragically destroyed during the draft riot in July 1863. (NYPL.)

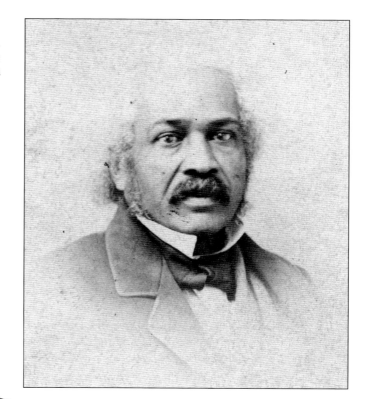

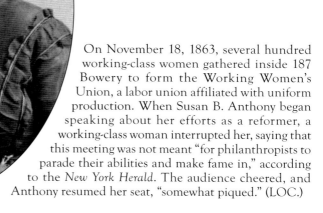

On November 18, 1863, several hundred working-class women gathered inside 187 Bowery to form the Working Women's Union, a labor union affiliated with uniform production. When Susan B. Anthony began speaking about her efforts as a reformer, a working-class woman interrupted her, saying that this meeting was not meant "for philanthropists to parade their abilities and make fame in," according to the *New York Herald*. The audience cheered, and Anthony resumed her seat, "somewhat piqued." (LOC.)

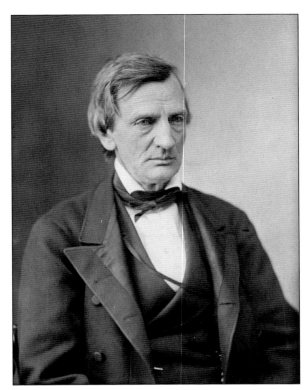

As chairman of New York's delegation to the Republican National Convention in 1860, William M. Evarts (1818–1901) magnanimously moved to make Lincoln's nomination unanimous. (New Yorkers had supported William H. Seward.) In 1865, he joined the team of prosecutors who sought to convict Jefferson Davis for treason. After the war, he led the fundraising effort for the pedestal of the Statue of Liberty. (LOC.)

John Winthrop Chanler (1826–1877), the fourth-great-grandson of Peter Stuyvesant, served in Congress as a Democrat from 1863 to 1869. George Templeton Strong compared Chanler to "vermin," concluding that Democrats like Chanler "are answerable for the death of every national soldier who dies for his country" because "their factious opposition" to Lincoln "keeps the rebellion alive." Chanler was censured by Congress in 1866 for his support of Andrew Johnson. (JW.)

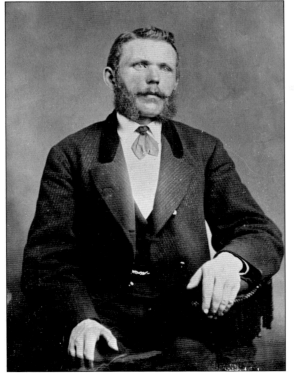

During the presidential election of 1864, Mayor Charles Godfrey Gunther (1822–1885), a Tammany Hall Democrat, faced criticism for vetoing resolutions by the city council calling for the illumination of the city in celebration of Union victories. Gunther explained that these "are not Union victories" but instead victories for Lincoln's emancipation policy. In response, Horace Greeley's *New-York Tribune* called Gunther a "Rebel partisan." (NPG.)

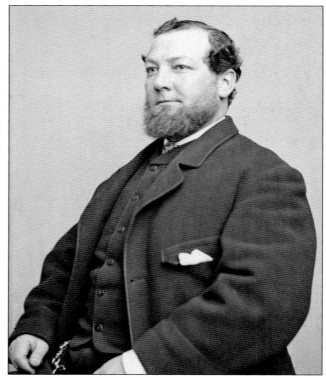

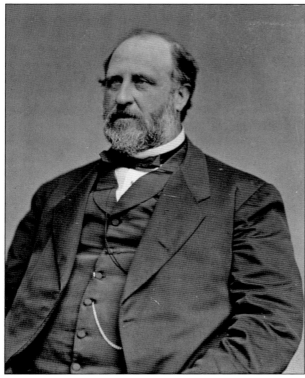

William M. "Boss" Tweed (1823–1870) grew up in a section of the Lower East Side known as Cherry Hill. As a young man, Tweed's abilities with an axe in a street fight caught Tammany Hall's attention, and he rose to become grand sachem. Tweed would unify the Democratic Party—and dominate city politics—setting up Tammany Hall as a political powerhouse for decades to come. (LOC.)

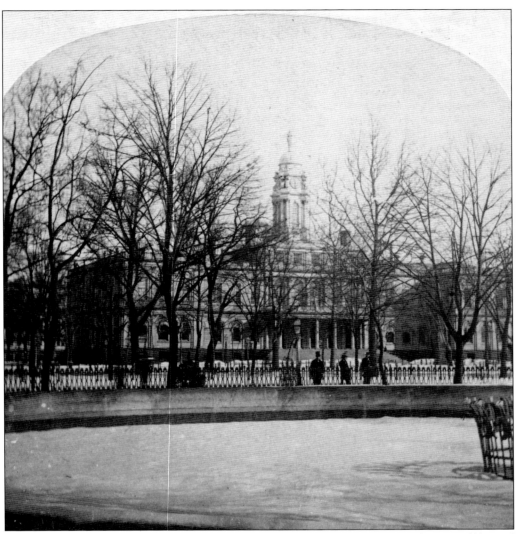

Built between 1803 and 1812—and still the home of the mayor's office—New York City Hall hosted President-elect Abraham Lincoln on February 20, 1861. There, Lincoln told Mayor Fernando Wood, "There is nothing that can ever bring me willingly to consent to the destruction of this Union, under which not only the commercial city of New York, but the whole country has acquired its greatness." During the war, City Hall also was a site of mourning. Col. Elmer Ellsworth's body would lie in state in the Governor's Room in May 1861 with the Confederate flag from Alexandria that he had died taking down—"pierced by a bayonet, and drenched with the blood of the brave Ellsworth"—on display near his corpse. Lincoln and Ulysses S. Grant would later lie in state at City Hall in 1865 and 1885, respectively. (LOC.)

Seven

Destroying the Atlantic Slave Trade

In 1808, the US government made it illegal for American sailors to participate in the transatlantic slave trade. In 1820, Congress declared slave trading an act of piracy punishable by death. Nevertheless, slaving voyages continued across the Atlantic for the next four decades, as heartless mariners kidnapped and transported African men, women, and children to Cuba, Brazil, and, in a few instances, the United States.

By the 1850s, New York City had become the financial center of the illicit transatlantic slave trade. Prior to Lincoln's inauguration, slave traders believed they had little to fear. Federal authorities generally turned a blind eye toward the slave trade, and no slave trader had ever suffered the full penalty of the law. Things changed rapidly after Lincoln's inauguration. In August 1861, US marshals from along the eastern seaboard gathered in New York City to discuss measures for catching slavers. US Marshal Robert Murray took them to the docks and showed them several vessels he had seized.

The most famous slaving case in American history is that of Nathaniel Gordon. On August 7, 1860, Gordon kidnapped 897 Africans—mostly women and children—from the coast of West Africa. Within hours, however, he was captured by a vessel of the Africa Squadron and sent to New York City for trial. Gordon rejected a plea deal from James Buchanan's prosecutor in Manhattan. Since no one else had ever been executed for the crime, he thought he had nothing to fear. But with Lincoln in the White House, Gordon soon learned that things would be different.

> Washington July 9. 1861.
>
> To the Senate of the United States.
>
> I nominate Robert Murray of New York (heretofore appointed in recess of the Senate, April 18. 1861) to be Marshal of the United States for the Southern District of New York in place of Isaiah Rynders, resigned.
>
> Abraham Lincoln

In 1861, Lincoln appointed Robert Murray the US marshal in New York City, and Murray developed a reputation for having "set his face against" the slave trade. He assembled a team of secret agents to watch the Manhattan docks for suspicious activities, also sending them to track slave traders all over the world. No image of Murray appears to survive. (NARA.)

Robert Murray worked closely with US Attorney E. Delafield Smith. A prominent mercantile lawyer in the city before the war, Smith was appalled by the wealthy families who had built mansions with money gained by kidnapping "human beings from their homes in Africa." He wondered, "Oh God! How many costly stone structures raise their ornamented fronts impudently to heaven, while their foundations are laid—literally laid—in hell." (LOC.)

William D. Shipman was a federal judge in Connecticut who regularly presided over trials in Manhattan. In 1861, Shipman heard the case of the *Augusta*, a whaling vessel that was suspected of being outfitted for the slave trade by Appleton Oaksmith. Shipman also presided over the two trials of Nathaniel Gordon. Although he was a Democrat, Shipman was a staunch opponent of the slave trade. (US District Court, Connecticut.)

Federal officials in Manhattan found an ally in Secretary of State William H. Seward, a former US senator from upstate New York. For the first year of the war, Seward oversaw the military arrests of political prisoners. While most of these arrests took place in the border states, some were in the North—including the arrest and detention of the suspected slave trader Appleton Oaksmith. (LOC.)

In 1861, Robert Murray arrested Appleton Oaksmith on the suspicion that he was buying old whaling vessels—including the *Augusta*—for use in the transatlantic slave trade. Oaksmith pleaded innocent, claiming that he wanted whale oil for a fish oil factory he worked at on Long Island. (David M. Rubenstein Rare Book and Manuscript Library, Duke University.)

Delafield Smith was ill when the trial of the *Augusta* began on August 13, 1861, so Assistant US Attorney Stewart L. Woodford prosecuted the case. While Woodford won the case (before Judge Shipman), he was indiscreet during the trial, sharing several meals with Oaksmith at Delmonico's at the corner of Broadway and Chambers Street. Robert Murray came to believe that Woodford was corrupt. (LOC.)

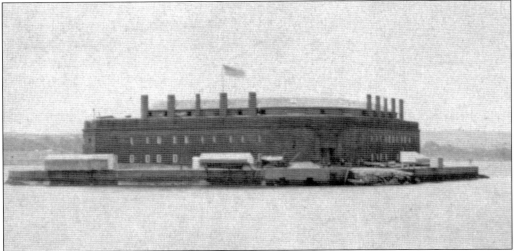

In November 1861, Oaksmith found himself imprisoned at Fort Lafayette in New York Harbor, which one newspaper described as "dismal and gloomy with no redemptive sign, save the beautiful flag which floats ever, from sunrise to sunset." The fort's imposing walls stood upwards of 50 feet tall with powerful heavy guns facing the channel. Throughout the war, political prisoners were housed in four small casemates and two larger battery rooms. (LOC.)

The US State Department hired New York police clerk Seth C. Hawley to investigate Oaksmith's case. Hawley reported that Oaksmith could be convicted in New York, but that a conviction was more likely in Boston, where he had outfitted another old whaler. Oaksmith was convicted in Boston in 1862 but escaped from jail and lived in exile until he received a pardon from Pres. Ulysses S. Grant in 1872. (Trudy B. Hawley.)

Initially, Nathaniel Gordon was imprisoned in the Eldridge Street Jail, where he was "dined and wined to an almost unlimited extent," according to various new reports. But when Murray became US marshal, he moved Gordon to the Hall of Justice, also known as "the Tombs"—a large granite structure built in 1838 (now the site of Collect Pond Park). One New York City guidebook stated that "the melancholy aspect of the building makes one give an involuntary shiver as he passes." (NYPL.)

After Nathaniel Gordon's conviction in November 1861, Judge Shipman told Gordon to "think of the sufferings of the unhappy beings" who, in "helpless agony and terror," had been so violently taken from their homes and families and placed aboard this ship, the *Erie*. Shipman said, "Remember that you showed mercy to none, carrying off as you did not only those of your own sex, but women and helpless children." (JW.)

Thousands of Northerners petitioned Lincoln for clemency in Gordon's case. Posters appeared in Manhattan reading, "Citizens of New York to Come to the Rescue" and "Judicial Murder." A gathering of citizens at the New York Merchants' Exchange sent Lincoln a telegram asking him "to commute the sentence of Nathaniel Gordon." The Merchants' Exchange, which was originally constructed beginning in 1836, is still located at 55 Wall Street. (NYPL.)

Lincoln decided to grant Gordon this two-week stay of execution so that Gordon might make "the necessary preparation for the awful change which awaits him." Lincoln warned the prisoner: "In granting this respite, it becomes my painful duty to admonish the prisoner that, relinquishing all expectation of pardon by Human Authority, he refer himself alone to the mercy of the common God and Father of all men." (NARA.)

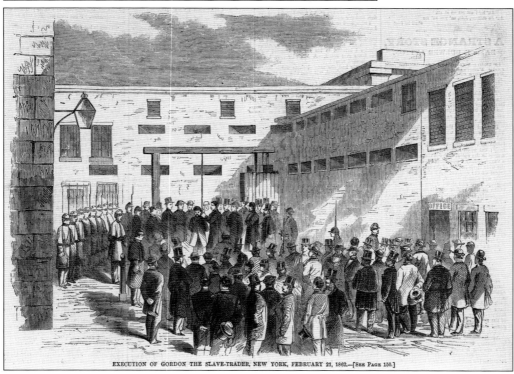

Just after noon at the Tombs, on February 21, 1862, the hangman pulled the cap over Gordon's face, adjusted the rope around his neck, and dropped the trap. When Gordon's body was examined afterwards, the *New York Times* reported that "the same meaningless smile sat on the blanched lip, while the same glassy look stared from the half-closed eyes." (LOC.)

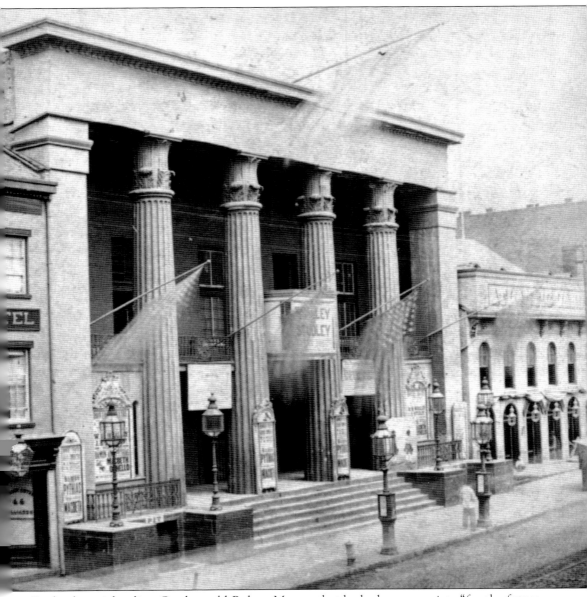

On his last night alive, Gordon told Robert Murray that he had more anxiety "for the future welfare of his family" than for his own fate. Murray assured Gordon that his family "should be well taken care of," and on March 21, a "sympathetic benefit to the widow and orphan child of the late Captain Nathaniel Gordon" was held at the Old Bowery Theatre, on the Bowery between Bayard and Canal Streets. (NYPL.)

In 1862, Secretary of State Seward negotiated a treaty with the British that allowed the Royal Navy to search American vessels for evidence of slave trading. The treaty also established courts of arbitration in several places around the world to help suppress the slave trade. Lincoln appointed Truman Smith, a former US senator from Connecticut, to preside over the court in New York City. (LOC.)

Edward M. Archibald (1810–1884) served as British consul in New York City from 1857 to 1883. Throughout the Civil War, he kept British authorities in London apprised of the arrests and trials of suspected slave traders in Manhattan. (LOC.)

Eight

THE DRAFT RIOTS

On March 4, 1863, the outgoing US Congress passed a new federal conscription act authorizing Provost Marshal General James Fry to draft citizens into the service of the US Army if their congressional districts failed to meet the War Department's manpower quota.

On July 9, Lincoln issued a call for 300,000 new recruits. Unlike the state-controlled draft, which had been put into place in August 1862, this draft went into effect immediately, without time for local communities to raise bounties or to meet their quota with volunteers. Fry sent six assistant provost marshals to New York City, and they spun the draft wheels on Saturday, July 11. On that first day, they called the names of several firemen, who, upon learning of their conscription, exhibited anger because their occupations had exempted them under the state draft. When the Ninth District draft office reopened on Monday, July 13, members of the Black Joke Engine Company 33 attacked it, poured turpentine on the floor, and set the building afire.

Spurred by this action, thousands of anti-war protestors assembled in the streets, attacking symbols associated with the Lincoln administration: Republican newspaper offices, off-duty Union officers, and uniform manufacturers. Within hours, the rioters began attacking African American residents as well. On the evening of the 13th, a mob ransacked and burned the Colored Orphanage Asylum on Fifth Avenue, and over the course of the next four days, rioters lynched 11 Black men (and one white woman married to a Black man), sometimes burning their victims alive.

After a dilatory response from the US Army and the state militia, troops arrived on the morning of July 14, and after three days of skirmishing, the soldiers subdued the chaos. By the time the mayhem ended, 119 people had been killed. In the end, the riot achieved little. Newspapers across the country castigated New York City's citizens for their ill temper. Mayor George Opdyke declared, "It is impossible to believe that the riot was anything else than the outbreak of traitors." On August 19, the assistant provost marshals resumed the draft, but conscripted men found it easy to avoid service. The 1863 draft conscripted 20,265 people from New York City. Of these, all but 2,623 procured exemptions or paid commutation. Another 875 procured substitutes. New York City's first draft held a mere 8.6 percent to service.

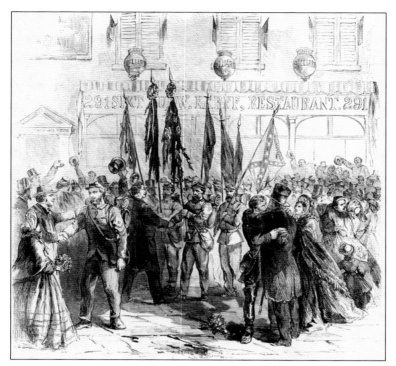

Between April and July 1863, eighteen veteran regiments returned to New York City, their tours of duty having ended. Their thinned ranks convinced some New Yorkers that victory was not worth its cost. This illustration depicts a scene on April 28, 1863, when the survivors of the 7th and 8th New York Volunteers returned to the city. The returning veterans shake hands with well-wishers who have arrived to congratulate them. (LFFC.)

On June 8, 1863, veterans from the 37th and 38th New York convened in the City Assembly Room to receive public thanks from Mayor George Opdyke, but one of the speakers, Judge John H. McCunn (seen here), hijacked the proceedings, stoking their rage against the Lincoln administration. Opdyke tried to regain control, but the soldiers booed him from the stage. McCunn later played a role in the draft riot by issuing writs to release rioters jailed by police. (LOC.)

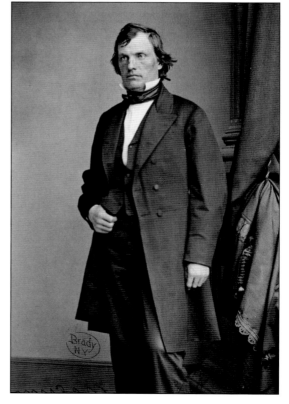

In December 1861, Republican George Opdyke won the city's mayoral race. During the war, he made a fortune as a government contractor. (His factory stood at the corner of Twenty-First Street and Second Avenue, and during the riot, a mob pillaged it.) In the aftermath of the draft riot, he offered a $500 reward for information leading to the arrest and conviction of rioters who committed murder. (LOC.)

Despite objections from Gov. Horatio Seymour, the US War Department proceeded with the federal draft. At 9:00 a.m. on July 11, 1863, Capt. Charles E. Jenkins, provost marshal for the Ninth District, commenced the draft in the 22nd Ward. An assistant spun the wheel, and a blindfolded clerk, Charles Carpenter, pulled the names. Jenkins had orders to draw 2,641 names but drew only 1,236 names before the close of business at 4:00 p.m. (LFFC.)

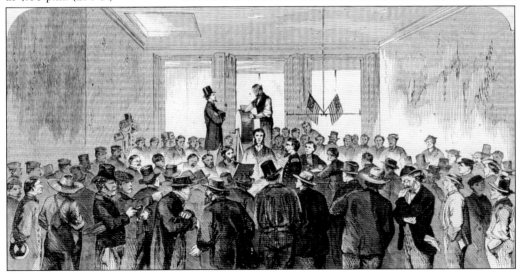

News of the draft shocked the people of New York City. Newspapers—such as this edition of the *Herald*—printed the names of those chosen. The timing could not have been worse. Only days before, casualty lists from the Battle of Gettysburg appeared in the papers. To many Democrats, it seemed as if the Lincoln administration simply needed more nameless bodies to feed the devastating maw of war. (LOC.)

Although state militia laws exempted firemen from mandatory service, the new federal law did not. At 10:30 a.m. on July 13, members of the Black Joke Engine Company 33 attacked the Ninth District Draft Office at Third Avenue and Forty-Seventh Street, displeased because one of their members had been drafted. They upset the wheel and set the building afire. Chief John Decker (seen here) was present at this protest, but once the fire spread to adjacent homes, he ordered his firemen to quell the blaze. (AO.)

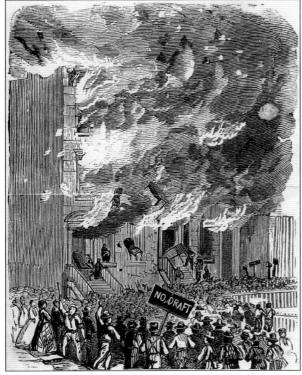

On the afternoon of July 13, a mob began sacking houses on Lexington Avenue between Forty-Sixth and Forty-Seventh Streets. This particular block of buildings did not hold any significance except that, by happenstance, the mob encountered Police Supt. John Kennedy traveling along it. The crowd recognized him and attacked, beating him on the head and dragging him by his hair through the mud. Stoked by the violence, other rioters looted and burned the nearby buildings. (NYPL.)

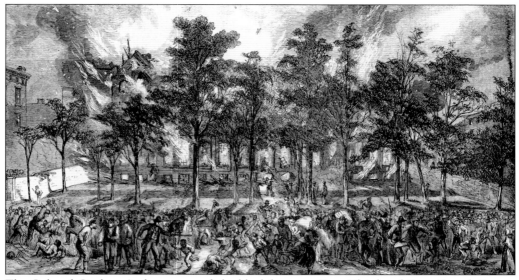

The Colored Orphan Asylum spanned the block between Forty-Third and Forty-Fourth Streets on the west side of Fifth Avenue. At 4:00 p.m. on July 13, the Lexington Avenue rioters attacked the asylum. Exactly what prompted them to do this is unknown, but one chronicler speculated, "There would have been no draft but for the war—and there would have been no war but for slavery. But the slaves were black, ergo, all blacks are responsible for the war. This seemed to be the logic of the mob." (LFFC.)

During the riot, the Colored Orphan Asylum housed 233 children—some of whom are photographed here. When the mob approached, Supt. William Davis barred the doors. Meanwhile, head matron Jane McClellan led the children out the back entrance. None of the children suffered injury. For the next three days, the 20th Precinct Building at Thirty-Fifth Street and Seventh Avenue housed the dispossessed orphans. (NYHS.)

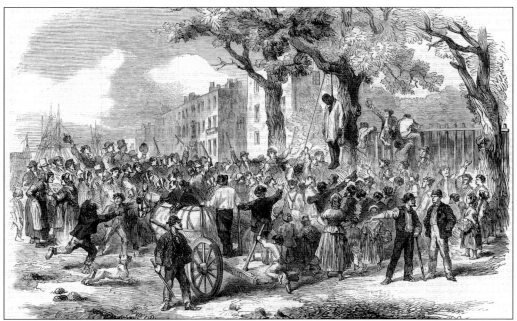

These illustrations depict the violent death of William Jones, a cartman who was murdered around 6:00 p.m. on July 13. Jones, who lived in Greenwich Village, had gone to purchase bread at a nearby bakery when he encountered a surly crowd that cornered him at the intersection of Clarkson Street and the Hudson River waterfront. The rioters beat him mercilessly, put a noose around his neck, removed his trousers, and hanged him from a tree along the sidewalk. As Jones died slowly, several men lit a wicker basket beneath him, and according to a police report, "he was literally roasted as he hung, the mob reveling in their demonic act." Jones's widow, Mary, later identified her husband's mutilated remains because, beneath them, she found a loaf of bread, the errand that had prompted him to leave the house that evening. (Above, NYPL; below, LFFC.)

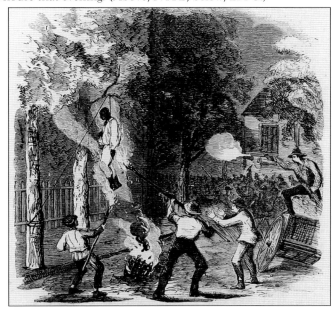

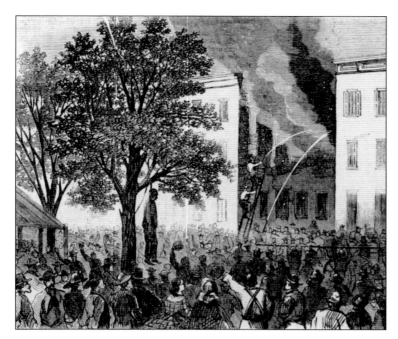

On the morning of July 14, a rioter chased Black shoemaker James Costello. Just as he was about to be overtaken, he fired his revolver in self-defense, mortally wounding his pursuer. The crack of the revolver drew a crowd. The mob surrounded him, beat him senseless, and then hanged him from a tree on Thirty-Second Street between Sixth and Seventh Avenues. After murdering Costello, the mob dragged his body through muddy gutters and burned it. (NYPL.)

On July 16, police gathered at the State Arsenal (Seventh Avenue and Thirty-Fifth Street), where many frightened Black residents had taken refuge. The police marched the Black residents down to the foot of Thirty-Fifth Street, placed them on boats, and sent them to Blackwell's Island (now Roosevelt Island), where they could be protected from the rioters. As time passed, more refugees encamped at Governors Island and at Bergen Point, New Jersey (pictured here). (JW.)

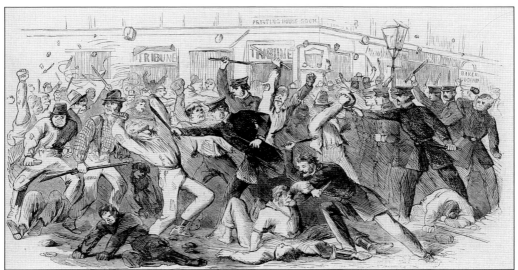

At dusk on July 13, a large mob assembled outside City Hall Park, across the road from the five-story *New-York Tribune* building at the corner of Spruce and Chatham Streets. At some point, someone shouted, "Down with it! Burn it!" The crowd heaved bricks through the windows until 150 police from Station 29 and from City Hall attacked the rioters with clubs, chasing them up Chatham Street. This represented one of the few victories for law enforcement. (LFFC.)

Col. Henry F. O'Brien was the highest-ranking fatality from the draft riot. Born in Ireland in 1823, he was commissioned as captain of Company H, 155th New York Volunteers, on October 12, 1862. On June 27, 1863, he received a promotion to colonel of the 11th New York Volunteers and opened an office in the city to recruit. On the morning of July 14, he rallied about 50 men with two howitzers and accompanied a force of police up Second Avenue. Near Thirty-Second Street, the mob attacked, prompting O'Brien to open fire with the howitzers. The shrapnel killed or wounded several civilians, including a woman with a baby in her arms. The crowd scattered, but news spread of what O'Brien had done. (NYSMM.)

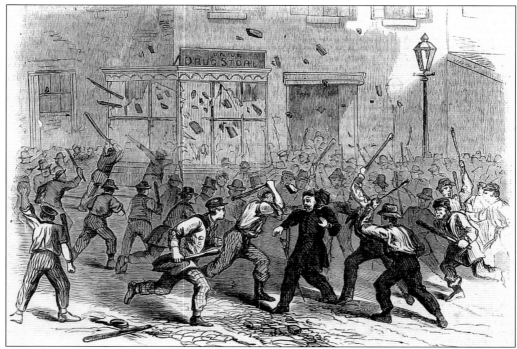

After dispersing the mob on Second Avenue, Colonel O'Brien excused his soldiers. Feeling ill, he walked unescorted to a drugstore on Thirty-Fourth Street. Rioters recognized him as he entered, and they assembled at the door to ambush him on his way out. As he exited, the crowd overpowered him, beating him mercilessly over the course of the next six hours. The mob kicked, stomped, and ran him over. They dragged him through mud, hanged him from a lamppost, stripped off his uniform, swung him from side to side, and pursued him—still kicking him—as he crawled to his backyard, where he died at 8:00 p.m. As one newspaper reported, "The body was mutilated in such a manner that it was utterly impossible to recognize it. The head was nearly one mass of gore, while the clothes were also saturated with the crimson fluid of life." O'Brien's body was consigned to a pauper's grave in Calvary Cemetery in Long Island City. (Above, LFFC; below, GB.)

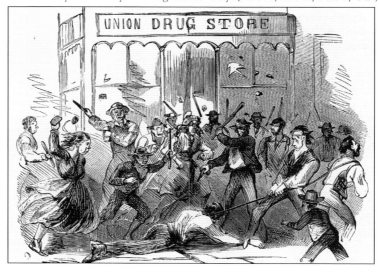

Maj. Gen. John Ellis Wool commanded the Department of the East, headquartered at Greene and Bleecker Streets. Since his arrival, he sent warnings to the War Department demanding more troops. But despite his own realization of the danger, Wool proved slow to react. On the first day, he sketched out orders to US troops but forgot to dispatch them. In the aftermath, Wool became the scapegoat for angry Republicans, and on August 1, Lincoln ordered him into retirement. (LOC.)

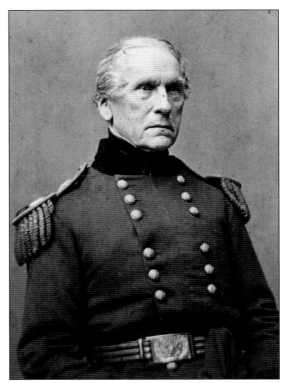

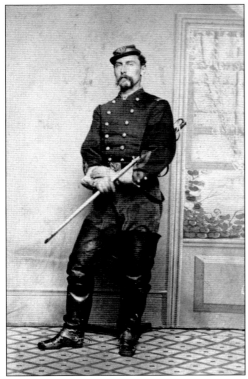

The first federal troops began arriving on the morning of July 14. Col. Cleveland Winslow of the 5th New York volunteered to lead the US Volunteers into action. On Nineteenth Street, he recognized one of his former soldiers among the rioters. Winslow wrote, "He took particular pains to select me for his mark & succeeded in wounding my horse in the neck. . . . I think I should more prefer having been engaged with the Rebs." (LOC.)

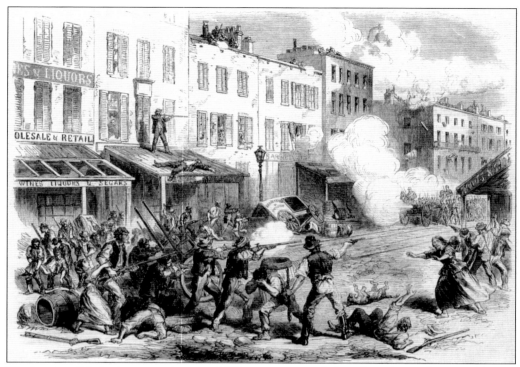

The heaviest fighting between rioters and US troops occurred along First Avenue between Twenty-Second and Twenty-Third Streets, where the rioters used a liquor store as their stronghold. Capt. Walter Franklin remembered: "The crowd grew more insolent, and increased firing as we advanced." After enduring several volleys, the crowd retreated to the roofs, "from which they kept up a fire for some minutes, but soon ceased altogether, as a number of them had been killed." (LFFC.)

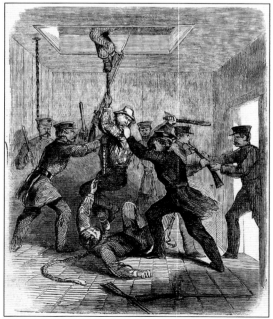

With a $500 reward being offered for information leading to the arrest of any murderers, the police began searches and seizures based on a legion of tips. In the ensuing weeks, police arrested about 450 people; however, the city's district attorney, Abraham Oakey Hall, did not favor prosecution. A Democrat, Hall vocally opposed the federal conscription act. Of those arrested, only 81 went to trial, and of those, only 67 faced conviction. (LFFC.)

After a five-week abeyance, New York City's draft resumed on August 19 at the Sixth District Office at 185 Sixth Avenue (shown here). This time, no trouble broke out. The drawing finished on August 28. For those nine days, the provost marshals drew 20,265 names from New York City. Of these, over 18,000 drafted men procured exemptions, paid commutation, or hired substitutes. New York City's first federal draft held a mere 8.6 percent to service. (JW.)

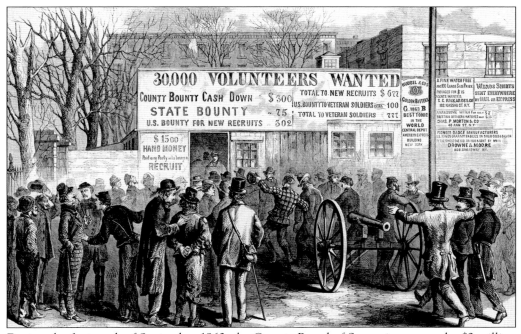

During the first week of September 1863, the County Board of Supervisors passed a $2-million ordinance to pay $300 enlistment bonuses—known as "bounties"—to each new volunteer. With this monetary inducement in place, so the theory went, the city could avoid a draft. In November, the state government added a $75 bounty, and the federal government added a bounty of $402. These bounty funds alleviated matters. By the end of March 1864, the city had overfilled its quota. (LFFC.)

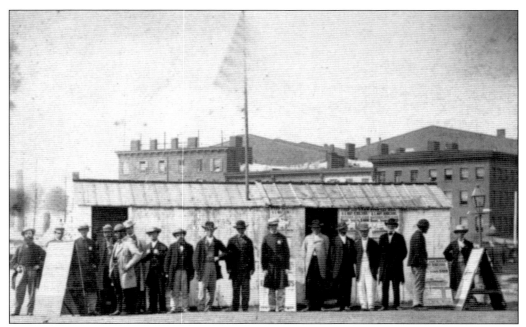

The creation of the bounty fund generated a criminal class known as "bounty brokers." As draft days neared, brokers purchased the services of men who were willing to go as substitutes, often taking a cut of their bounty in the process. When drafted men required these substitutes, the brokers sold their services at inflated prices. Here, bounty brokers have established a "U.S. Navy Rendezvous" on the Battery. (LOC.)

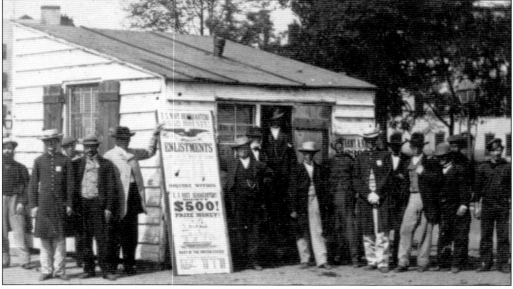

Here, another dilapidated shack serves as a US Navy Rendezvous. It promises $500 prize money (to be awarded if—and only if—a sailor's ship impounded an enemy vessel on the blockade). Some brokers transformed their organizations into criminal syndicates that fleeced the federal, state, and county governments out of millions of dollars. They committed acts of violence upon anyone who attempted to investigate their misdeeds. (LOC.)

Nine

Gotham's Black Soldiers

New York City's effort to recruit African American soldiers came late. Although the state constitution of 1846 made no mention of race, New York's militia laws (including its April 23, 1862, revision) expressly stated that only "able-bodied, white male citizens" could serve in the militia.

In 1863, as several free states began relaxing their restrictions on Black recruiting, New York's governor, Horatio Seymour, refused to follow suit. To placate Democratic voters, he vowed never to authorize Black recruitment. But the draft changed matters. After Lincoln announced another call for troops on October 17, 1863, sixty-six wealthy New Yorkers petitioned the president, advising him to overrule the governor because, in their opinion, Black recruiting was the only way to meet the city's quota without conscription. If Black New Yorkers could not be counted, the new draft, they said, "will fall heavily upon those who are left."

These arguments appealed to Lincoln's secretary of war, Edwin Stanton, who, on December 10, appointed federal recruiters to Riker's Island to begin raising regiments of US Colored Infantry (USCI). This recruiting drive resulted in the formation of three regiments: the 20th USCI, the 26th USCI, and the 31st USCI. New York's records indicated that 4,125 African Americans enlisted in these regiments; however, only 224 listed New York State as their place of residence.

The 20th USCI left for the front in March 1864 and served in the Department of the Gulf until October 1865. It fought in no major engagements but lost heavily from disease. The 26th USCI also departed its camp of instruction in March 1864 and reported to the Department of the South, the military subdivision that occupied the South Carolina Lowcountry. It participated in a dozen battles and skirmishes, losing 30 officers and enlisted men killed or mortally wounded in action. The 31st USCI left in May 1864, joining the Army of the Potomac. It experienced the heaviest combat of the three, confronting rebel soldiers during the Sieges of Richmond and Petersburg. It lost 181 officers and enlisted men, half from disease or accident and half from combat.

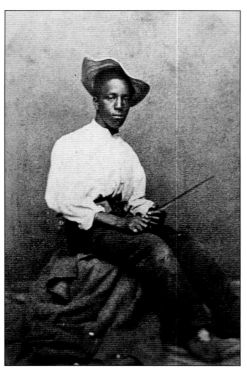

New York's state militia laws forbade African Americans from enlisting. However, some Black New Yorkers found ways to join the war by stowing away with the militia. These men did not enlist, per se; nearly all of them served as hired valets for white officers. This image depicts one such man, an unidentified New Yorker who became known as the "pet" of the 7th New York State Militia. (Thomas Harris Collection.)

Once at the front, New York City's militiamen began recruiting local runaways (commonly known as "contrabands") to serve as servants, cooks, commissaries, and mule drivers. This photograph, taken in May 1861 at Camp Cameron, depicts a mess belonging to the 7th New York State Militia. The unidentified African American child seated at the front likely served as this contingent's mess cook. (LOC.)

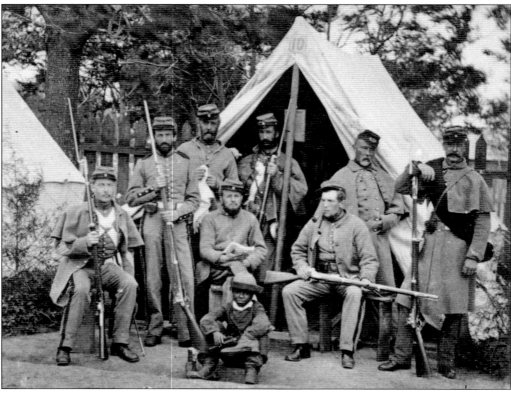

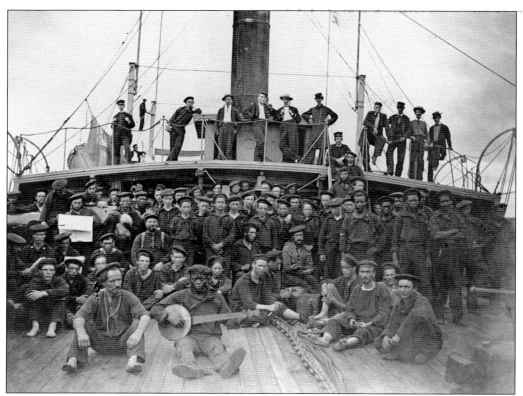

Black New Yorkers who wished to serve right away could enlist in the US Navy. This image depicts the crew of USS *Hunchback*—a New York City ferry converted into a gunboat— during a pause in operations along the James River in 1864. Most of *Hunchback*'s African American contingent came from Baltimore; however, six of them—Landsmen William Brown, Thomas Colter, Radford Livingston, Morris James, William Nixon, and Alexander Rice—all enlisted in New York City. (NHHC.)

Dozens of Black New Yorkers traveled to Massachusetts to enlist in two newly formed segregated regiments, the 54th and 55th Massachusetts. Among them was Peter Vogelsang, who, at the age of 44, enlisted in Company H, 54th Massachusetts. On July 16, 1863, at the Battle of Grimball's Causeway, Vogelsang received a gunshot wound to the chest. He survived and returned to his regiment, becoming its quartermaster. He ended the war as a first lieutenant. (Smithsonian National Museum of African American History and Culture, gift of the Garrison family.)

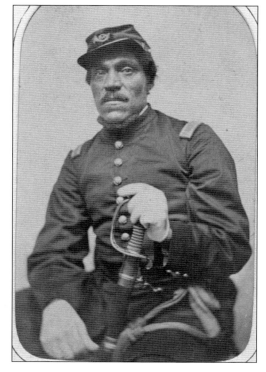

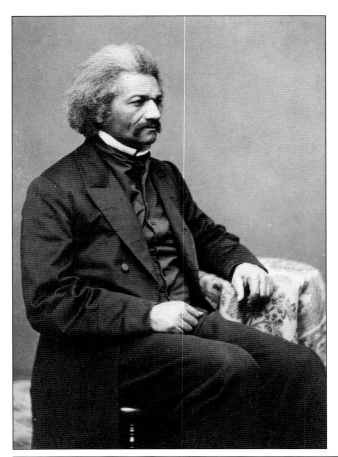

On February 6, 1863, Frederick Douglass spoke to a riveted crowd at the Cooper Union. He emphasized the need to defy the governor and enlist African American soldiers. Douglass declared, "I know the colored men of the North; I know the colored men of the South. They are ready to rally under the stars and stripes at the first tap of the drum. Give them a chance; stop calling them 'niggers,' and call them soldiers." (LOC.)

In May 1863, the city's abolitionists formed an organization called the Association for Promoting Colored Volunteers (APCV). They petitioned President Lincoln to allow their organization to begin recruiting African American regiments. On December 3, Lincoln gave his consent to the APCV. This poster informs potential recruits where they can go to enlist. (The American Social History Project.)

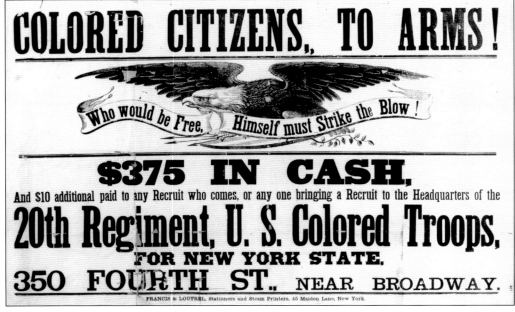

New York's African American regiments encamped on Riker's Island (pictured here). The APCV organized three regiments: the 20th, 26th, and 31st US Colored Infantry. The 20th USCI moved onto Riker's Island on February 9, 1864, and the 26th USCI departed on March 27. Meanwhile, the 31st USCI encamped on nearby Hart's Island. (LFFC.)

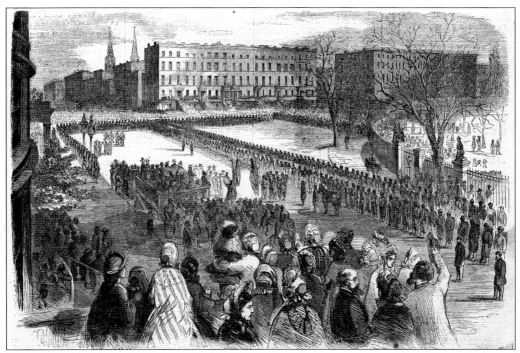

On March 5, 1864, at 9:00 a.m., the 20th USCI boarded a steamer and landed at the foot of Twenty-Sixth Street. It marched to Union Square, where the Union League Club had erected a speakers' platform to present the regiment with its battle flag. The *Times* could not help but notice the profound political change. Now, "a thousand of these despised and persecuted men march through the city in the honorable garb of United States soldiers." (LFFC.)

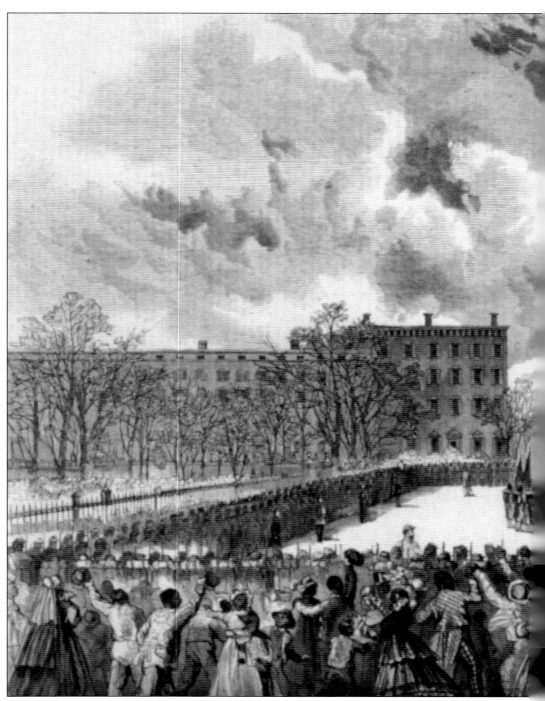

The presentation ceremony for the 20th USCI began at 1:00 p.m. Charles King, the president of Columbia College, delivered the keynote address. He said, "You are in arms, not for the freedom and law of the white race alone, but for universal law and freedom; for the God-implanted right of life, liberty, and the pursuit of happiness to every being whom He has fashioned in His own

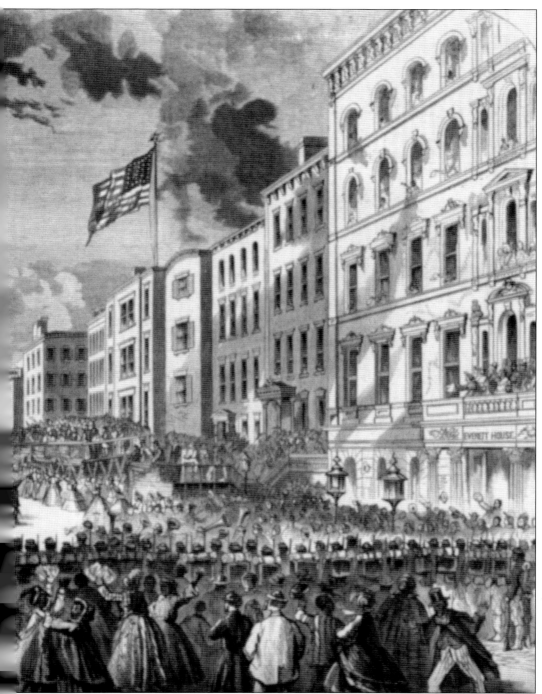

image. When you put on the uniform and swear allegiance to the standard of the Union, you stand emancipated, regenerated and disenthralled; the peer of the proudest soldier in the land." After concluding his speech, the women of the Union League Club handed the national and regimental banners to the color guard. (LFFC.)

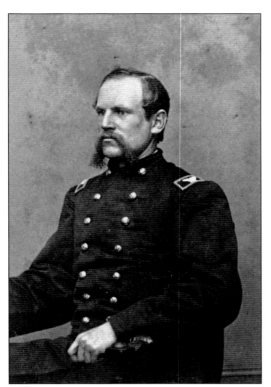

Col. Nelson B. Bartram, a teacher from Port Chester, New York, commanded the 20th USCI. When the 20th USCI received its battle flags at the Union League Club, he remarked, "It has been the habit of those among us who sympathize with the traitors now in arms against us to sneer at what they are pleased to term the cowardice of the negro. I hope that Port Hudson, Fort Wagner, and Olustee have forever settled this question." (LOC.)

Born out of wedlock to a Black woman and a white man in 1825, Paschal B. Randolph was orphaned and living on the streets near Five Points by the early 1830s. In 1863, Randolph began recruiting African American men into the Union army, saying, "We should strike, and strike hard, to win a place in history, not as vassals, but as men and heroes." (GB.)

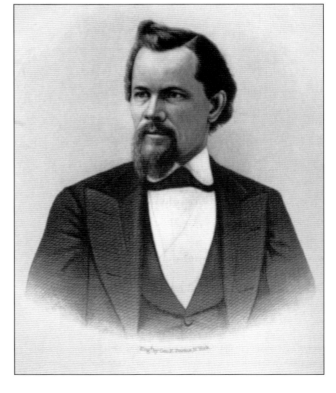

Photographs of soldiers from New York City's US Colored Infantry regiments are exceedingly rare, but this one is well preserved. It depicts Hospital Steward Thomas H.S. Pennington (left) and Sgt. Maj. William L. Henderson (right), both members of the 20th USCI. This image was taken at a gallery in New Orleans, where their regiment performed garrison duty. In 19 months of service, the 20th USCI lost 264 officers and enlisted men to disease. (LOC.)

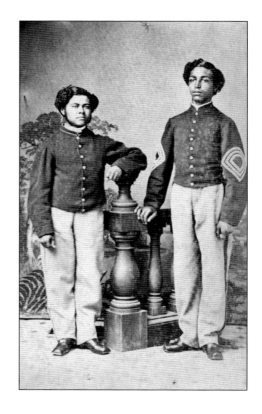

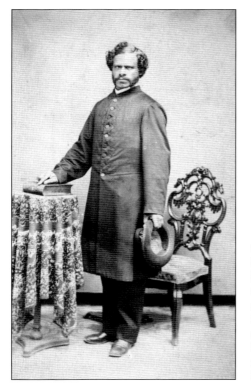

George Washington LeVere was born in New York City on October 9, 1820. He served as pastor of St. Paul's Congregational Church in Flatbush and as president of the African Civilization Society, an organization dedicated to combating Black illiteracy. In 1864, he received an appointment as chaplain of the 20th USCI. Once deployed, LeVere wrote to newspapers on behalf of his men, bringing attention to racial inequality inside the US Army. (Cowan Auctions.)

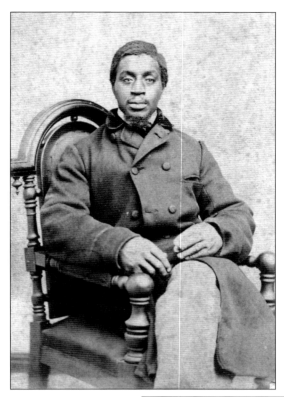

Benjamin Benson was born in 1842 in Old Bridge, New York. On December 5, 1863, at the age of 21, he enlisted in Company C, 20th USCI. Benson's regiment spent much of the war guarding forts along the Mississippi River. Although his regiment endured months of boredom and disease, the soldiers experienced high times when they confiscated rebel property, occupying stately abandoned homes. (Donald Wisnoski.)

On Easter Sunday 1864, the 26th USCI unloaded at the foot of Warren Street to receive a stand of colors (one of them is seen here) in a ceremony conducted by the Union League Club. Club member John Jay delivered the remarks. He said, "When the story of your prowess is told by the daily press or on the page of history, this metropolis will share in your triumph, and the Empire State count you proudly among her sons." (NYSMM.)

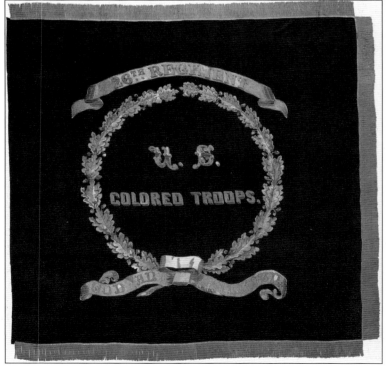

Col. William Silliman commanded the 26th USCI. When he received the 26th USCI's battle flags, he announced to the audience: "For myself, I feel that what a man has been is nothing to what he yet may be, and by the latter I will strive to merit the honor so heaped upon me here today." On December 9, 1864, Silliman was mortally wounded at the Battle of Tulifinny. He died in Beaufort, South Carolina, eight days later. (Roger Hunt.)

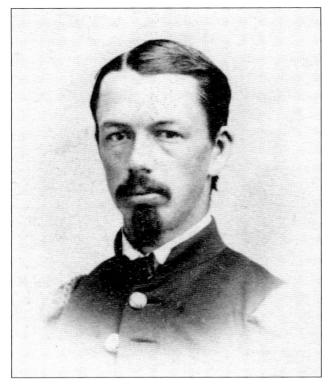

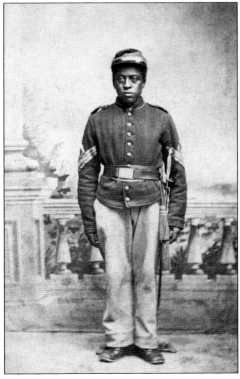

This photograph depicts 1st Sgt. Luther C. Hubbard of Company C, 26th USCI. He was photographed near the end of the war by Samuel Abbot Cooley, who served as a photographer for the Union army's 10th Corps. Cooley photographed sites in Jacksonville, Florida, and Hilton Head and Folly Island, South Carolina. This image may have been taken at one of those locations, but it was more likely taken in Beaufort, where the 26th USCI spent the last months of the war. (LOC.)

Born free in Kentucky in 1820, Benjamin Franklin Randolph graduated from Oberlin College in 1857 and became chaplain of the 26th USCI in 1863. After his regiment disbanded, Randolph remained in South Carolina to assist in redrafting the state's postwar constitution. He won election to the South Carolina Senate and served as a national elector. On October 16, 1868, while changing trains in the midst of a campaign tour, he was assassinated by the Ku Klux Klan. (LFFC.)

David Carll was born in Cold Spring, New York, in 1843. On January 2, 1864, he enlisted in Company I, 26th USCI. Five days after enlisting, Carll took his $300 enlistment bounty and purchased land for himself at Oyster Bay on the northern coast of Long Island. Carll survived the war and returned to Oyster Bay, occupying land that became known as Carll Hill. He was married twice, fathered eight children, and died in 1910. (NARA.)

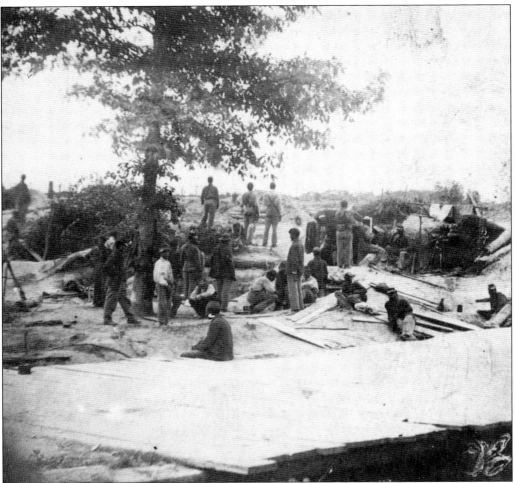

On May 18, 1864, the 31st USCI joined the Army of the Potomac, the high-profile army that campaigned in Virginia. When the 31st arrived, about 400 men from an incomplete battalion—the 30th Connecticut—were consolidated into it. The 31st USCI joined the 4th Division, 9th Corps, which contained eight other African American regiments. Beginning in June, the 4th Division participated in the Army of the Potomac's siege operations around Petersburg, Virginia. This photograph, taken some time during the summer of 1864, depicts a cluster of Black soldiers from the 4th Division lounging beside their subterranean burrows behind the Union siege lines. Unfortunately, the regiment to which they belong is unknown. (LOC.)

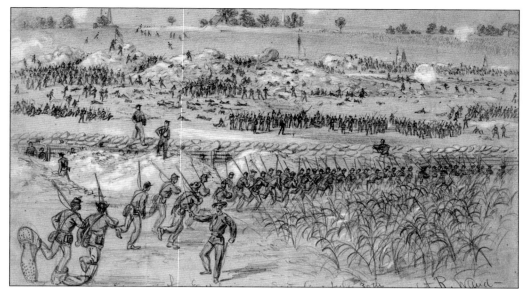

On July 30, 1864, Confederate soldiers routed the 4th Division at the Battle of the Crater. During the chaos, the 31st USCI lost 135 officers and enlisted men, including some men killed by the Confederates after they surrendered. This sketch depicts the scene. The Confederate earthworks are in the background. One of the USCI regiments marches in column, at the double-quick, in the foreground. For an unknown reason, artist Alfred Waud drew one soldier with comically large shoes. (LOC.)

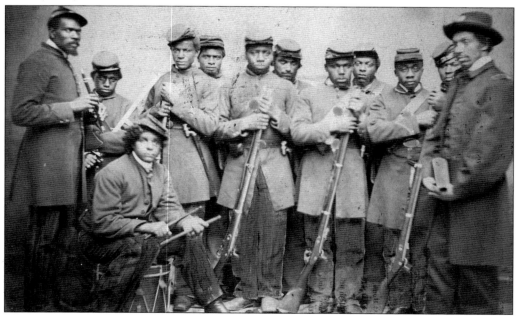

This image depicts 12 men recovering from wounds at L'Ouverture Hospital in Alexandria, Virginia. They came from nine different US Colored Infantry regiments, but two of them—Musician Tobias Trout (far left, holding a fife) and Pvt. George H. Smith (front rank, far right, holding a rifled musket)—belonged to New York's 31st USCI. Both men had been wounded at the Battle of the Crater. (Charles T. Joyce Collection.)

Ten

THE GREAT METROPOLITAN FAIR

In late 1863, the US Sanitary Commission started raising money for soldiers and their families through large fairs, or bazaars, in cities throughout the North. The president of the Sanitary Commission, Henry W. Bellows, wanted the one in New York City to be "on a National scale—its magnitude and results worthy of the occasion, the place, and the necessity." Moreover, the New York City fair must "be universal," appealing to the rich and the poor, and "democratic, without being vulgar; elegant without being exclusive; fashionable, without being frivolous; popular, without being mediocre." In the end, there must be "something for everybody to do, something for everybody to buy" so that all people from the city could come out and support the Union cause.

On the morning of November 21, 1863, fifty or sixty women met at the Union League building to begin planning the grand affair. Two executive committees, one run by men and another run by women, did the planning. For the next few months, volunteers raised contributions, contracted with vendors, and gathered donations. By late March 1864, George Templeton Strong observed that "the whole city is bubbling and fizzing with the Fair and the Sanitary Commission."

The fair opened with speeches and military parades on a bright and sunny Monday, April 4. Mayor C. Godfrey Gunther issued a proclamation recommending that the day be observed "as a holiday, and that all business, except works of charity and necessity, be suspended." Over the next few weeks, tens of thousands of people walked through the buildings, marveled at the displays, and spent money on all manner of goods. By the time the fair closed on Saturday, April 23, it had raised $1,340,050.37. When the $163,378.47 in expenses were deducted, net proceeds amounted to $1,176,671.90.

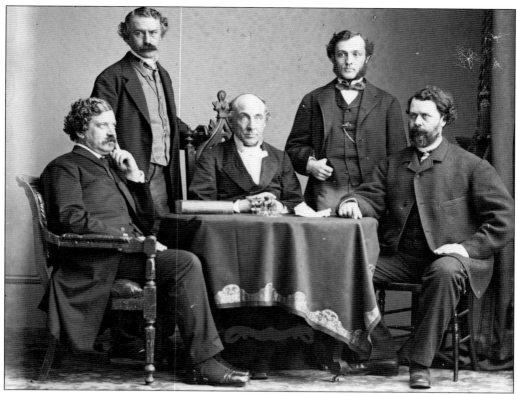

This photograph depicts the US Sanitary Commission's executive committee. From left to right are Dr. William Holme Van Buren, George Templeton Strong, Rev. Henry W. Bellows, Dr. Cornelius R. Agnew, and Prof. Wolcott Gibbs. Strong complained that the planning of the fair led to "gossip, intrigue, and personal pique" that was "stupendous and terrible." (LOC.)

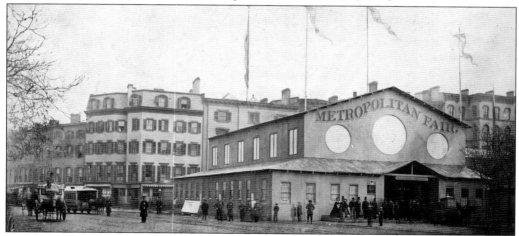

The fair building erected at Union Square housed the Children's Department, the Knickerbocker Kitchen, the International Department, and the Musical Instrument Department. As preparations were finalized, George Templeton Strong said the volunteers were "working their fingers to the bone" in the "busiest human anthill I ever saw." This photograph is by Otto Ebbinhaus & Swift. (Thomas Harris Collection.)

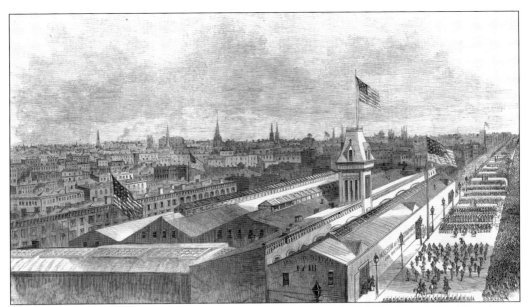

Shortly after noon on April 4, a "melodious clashing of bands" could be heard as soldiers began to gather on Fourteenth Street (seen here), where the city had erected temporary buildings near Sixth Avenue in front of the armory of the 22nd New York National Guard. Newspapers estimated that 8,000 men marched in the procession and were viewed by a half-million spectators. (NYPL.)

Six thousand tickets were sold at $2 apiece for the opening ceremony. After the "Star-Spangled Banner" and a prayer, the multitude sang Oliver Wendell Holmes's "Army Hymn." Maj. Gen. John A. Dix and Joseph H. Choate delivered short addresses acknowledging the role the women had played in putting on the fair. The crowd sang the "Hallelujah Chorus" from Handel's *Messiah* and "Old Hundred" and then visited the various galleries. (LFFC.)

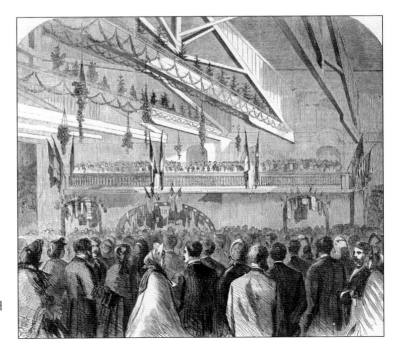

Lovers of good ice cream found much to enjoy at the fair. Patrons frequented ice-cream stands in both the International Department and the Children's Department, and the Fair Restaurant had vanilla, strawberry, lemon, and chocolate available at all times for 15¢. In this photograph, three women run one of the stands, while a boy leans on the counter, ready to place his order. (LOC.)

Flavored syrups and sarsaparilla were available for 10¢ per glass at the soda water stand. The *Spirit of the Fair* newspaper reported that the soda water stand had a placard which stated, "no change given." According to this report, "A gentleman drank his glass of soda water, and tendered a $2 bill; no change being given him, he drank out the balance." (LOC.)

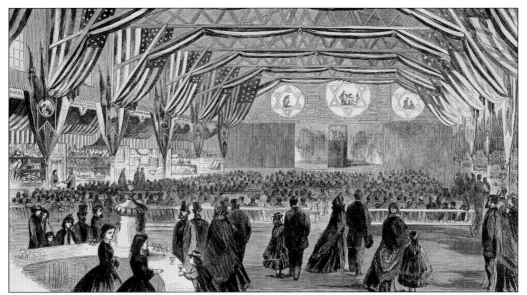

The Children's Department featured booths that were "especially calculated to meet the wants of the little folks," including toys, books, a miniature ice-skating pond, a tiny ballroom, and sweet treats, which one witness said were "viewed with unceasing longing by the children, but [were] not so attractive to their guardians and doctors." Even the "withered, weary face[s]" of the elderly grew "bright again" as they enjoyed the festivities. (LFFC.)

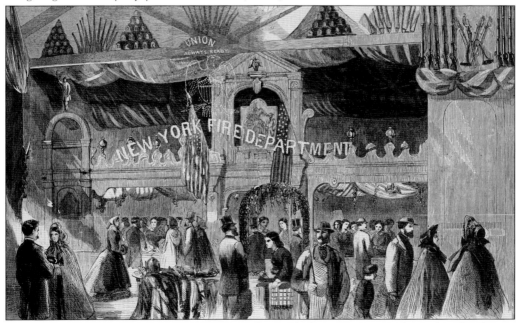

The fair featured displays of clothing, carriages, dry goods, boats, sewing machines, burglar alarms, and all sorts of "mechanical contrivances." The New York Fire Department featured statues of firemen, rows of signal lanterns, and shields bearing the names of battles in which New York's Fire Brigade had fought. Above the display, near the rafters, were the tools of the fireman's trade—hooks, ladders, hoses, axes, torches, and pyramids of firemen hats. (LFFC.)

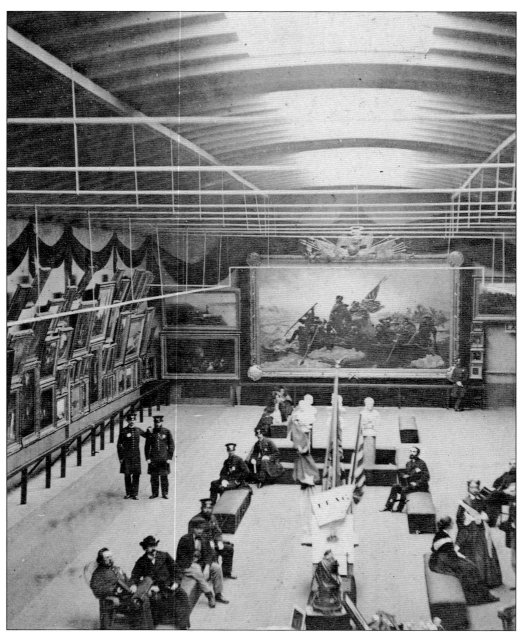

One observer described the Picture Gallery as "a large, pleasant room, high and well lighted, and filled with works bearing, for the most part, the most honored names in American art." The only drawback for the exhibit was that at times it was so crowded that spectators had difficulty seeing the works hanging on the walls. Among those on display were Frederic Edwin Church's *Niagara* and *Heart of the Andes*, Albert Bierstadt's *Rocky Mountains*, and Emanuel Luetze's *Washington Crossing the Delaware*, which is prominently featured in this photograph by J. Gurney and Son. Among the many artists in attendance at the fair was photographer Mathew Brady. A souvenir book titled *Recollections of the Art Exhibition, Metropolitan Fair, New York* features photographs of much of the artwork that was on display. It can be viewed online at the Smithsonian Institution's website. (Getty Museum.)

High society women of New York City came to the fair dressed to impress. In his diary, George Templeton Strong wrote, "It was a pretty sight: the throng of well-dressed people, the showy decorations, the stalls or counters loaded with all sorts of things, and especially the shoals of nice women with their graceful, diagonal, broad blue ribbons . . . all working in such deadly earnest." (LFFC.)

In the Indian wigwam, Native Americans put on "several entertainments," such as this war dance. *Harper's Weekly* noted the irony that these dancers "only a little while ago, held undisputed possession of our continent," but they now performed "for the pleasure of the pale-faced race, whose ancestors pushed them into obscurity and historical oblivion." This photograph is by J. Gurney and Son. (Getty Museum.)

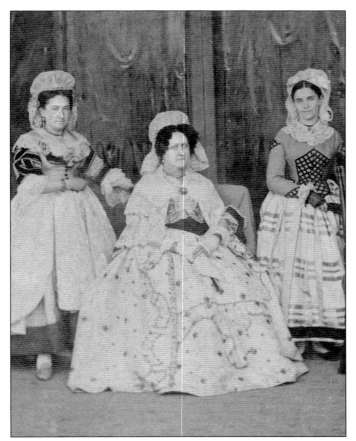

The Knickerbocker Kitchen in the Union Square building contained artifacts and artwork that reminded patrons of when Manhattan was Nieuw Nederlandts. Meals in this restaurant were served up in the "Knickerbocker style" by women dressed "in the apparel of the old times," while Knickerbocker gentlemen visited each night to smoke pipes and discuss the affairs of the day. However, not everyone was excited to participate in the festivities. Maria Lydig Daly noted that she "did not particularly fancy the idea of being seated in cap, short gown, and petticoats, pouring out tea for all the rabble that (in such a great city) would come to give their mite to the Sanitary Commission." When Daly saw her friend dressed up, she wrote that it "made her look like an old woman." (Left, Getty Museum; below, LFFC.)

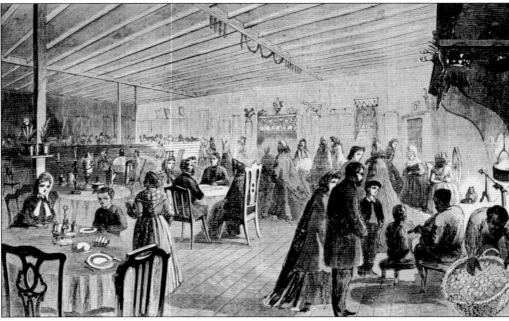

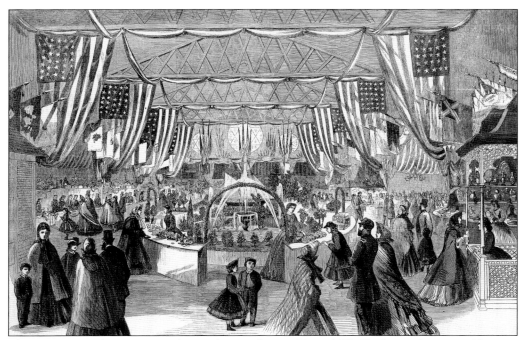

The International Department featured, according to *Harper's Weekly*, "rare selections of Science and Art contributed from different countries" as well as a beautiful fountain. George Templeton Strong said it "is quite gorgeous with its banners and escutcheons, its fountain, and its show of flowers. Who dreamed two years ago last June that the poor little Sanitary Commission would ever make such a noise in the world?" (LFFC.)

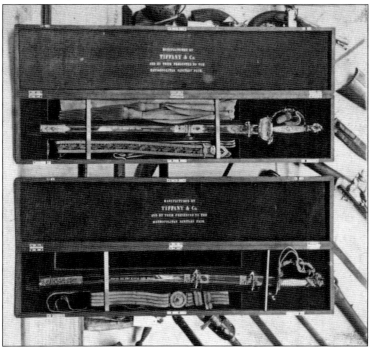

Two Tiffany's presentation swords, one army and one navy, were displayed at the fair, and for $1, attendees could vote on the recipients. The voting for the army sword made national headlines since one of the contenders, George McClellan, was expected to become the Democratic presidential nominee. McClellan led for most of the fair, but Ulysses S. Grant overtook him in the end. Naval officer Stephen Clegg Rowan won the navy sword. (NYPL.)

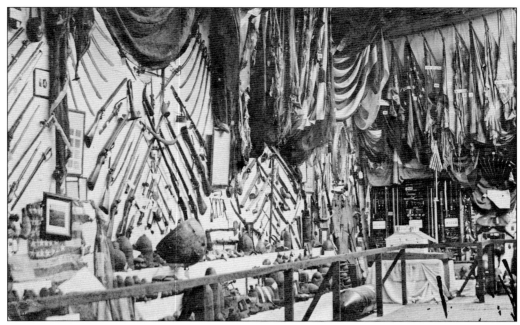

The Department of Arms and Trophies was "very near the heart of most visitors," wrote one observer, because it was "more intimately, than any other department, connected with the struggle whose needs had raised these buildings." Among the many "Revolutionary Relics" on display were a powder horn that had been owned by Benedict Arnold; spontoons, blunderbusses, bayonets, swords, and flags; guns and other artifacts from Bunker Hill, Saratoga, and Yorktown; weapons that had been captured from the Hessians at Trenton, New Jersey; a nail from the executed British spy Maj. John Andre's coffin; the Marquis de Lafayette's sword, camp kettle, and looking glass; and George Washington's sword, coat, vest, breeches, camp chest, writing case, teaboard, fire shovel, dishes, and cane. The photograph above is by J. Gurney and Son, and the one below is by E. & H.T. Anthony. (Above, Getty Museum; below, NYPL.)

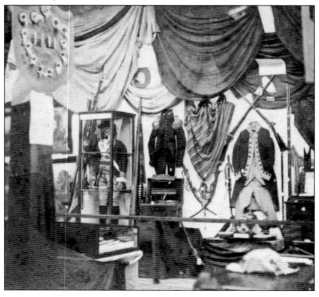

Eleven

The Election of 1864

The election of 1864 stands out as the most consequential political contest in American history. Never before had the United States held a nationwide popular election during wartime. Never before or since had so much been at stake in an election. Indeed, the fate of the nation stood in the balance.

In June 1864, the Republican Party met in Baltimore and nominated Abraham Lincoln as its candidate. The convention dumped the current vice president, Hannibal Hamlin of Maine, and replaced him with Andrew Johnson, a War Democrat from Tennessee. The convention also adopted a platform pledging to amend the Constitution to abolish slavery. During the election, the Republicans ran as the Union Party in an attempt to win the votes of pro-war Democrats.

When the Democrats met in Chicago in late August, they sensed how war-weariness had increased in the North. Anti-war sentiment had become so strong, in fact, that Lincoln was convinced he would lose in November. The Democrats nominated the pro-war but proslavery George B. McClellan for president and Congressman George H. Pendleton, a Peace Democrat from Ohio, for vice president. Their platform boldly called the war effort a "failure."

Had the Democrats waited just a few more days to convene, they likely would have written a different platform. In early September, Maj. Gen. William T. Sherman's armies finally captured Atlanta, making the possibility of Union victory appear all but certain. Northern disenchantment with the war soon evaporated, and Lincoln coasted on this military victory to an electoral landslide on November 8, 1864. Lincoln's reelection—as much as any victory on the battlefield—sealed the doom of the Confederacy and pointed toward a restored Union free of the blight of slavery.

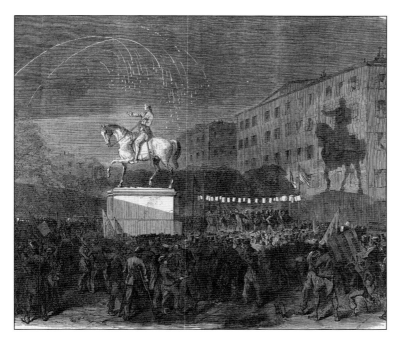

Democrats held a rally at Union Square on September 8 to "ratify" McClellan's nomination. Five large stands stood on the south side of the square, and speakers harangued the attendees while "brilliantly lighted with Chinese lanterns." Skyrockets burst above the statue, creating showers of sparks. The boys in the foreground are selling McClellan badges for 15¢ apiece. Local artist C.D. Shanly sent this sketch to the *London Illustrated News*. (JW.)

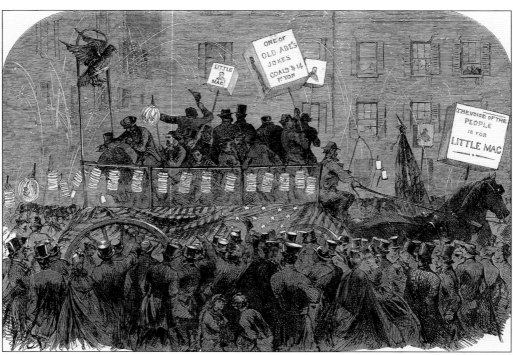

On September 16, Democrats held "another tremendous demonstration" in support of McClellan. According to Shanly, the cannons were louder and the fireworks "more brilliant and complicated" than he had ever seen before. "There was an endless torchlight procession . . . and the torches, every now and then, discharged globes of fire and showers of sparks in the air. All was a blaze of many-coloured light." (JW.)

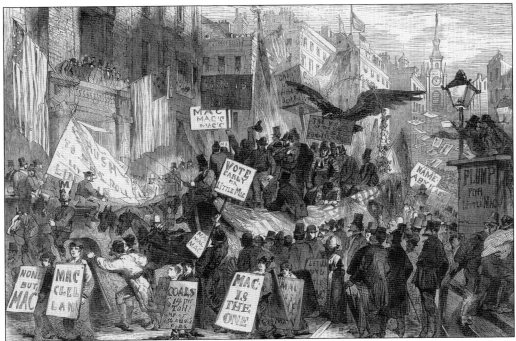

A large number of wagons decked with American flags and illuminated with lanterns crowded the city streets on September 16. According to Shanly, the crowd groaned when this wagon passed and they saw the transparency that said, "Coal, $14 per ton." Another witness noted that "the neighbouring bars were full to overflowing," while small boys climbed the branches of trees to watch the proceedings. (JW.)

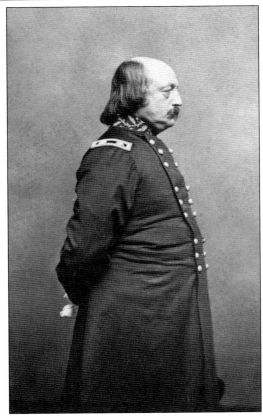

Fearing violence on Election Day, Secretary of War Edwin Stanton dispatched 5,000 troops from Virginia to New York, commanded by Maj. Gen. Benjamin Butler. In an order issued on November 5, Butler declared that his troops "are safeguards of constitutional liberty, which is freedom to do right, not wrong. They can be a terror to evil doers only." Many Democrats feared that "do right" meant vote for Lincoln. (LOC.)

On the morning of Election Day, Capt. Jeremiah Petty of the municipal police force oversaw the transportation of the ballot boxes from the police station in the Fifth Precinct to the polling places. Petty had joined the force as a patrolman in 1857 and was promoted to captain in 1861—a rank he held until his retirement in 1887. (JW.)

Elections in the mid-19th century were handled very differently from elections today. The parties printed the ballots, and voters procured them from party operatives at the polls. This image shows the "ticket booths" where Republicans and Democrats could get their respective ballots. (JW.)

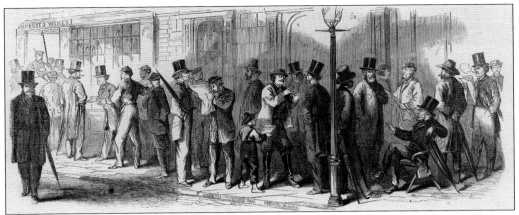

"Readers! we exhort you to be among those who go EARLY to the poll this morning," trumpeted the *New-York Tribune* on Election Day. "There patiently, earnestly, inoffensively await your turn to vote. That is the first duty of the day." In New York, African American men who owned property could vote, such as the Black voter who leans against the lamppost in this image. (JW.)

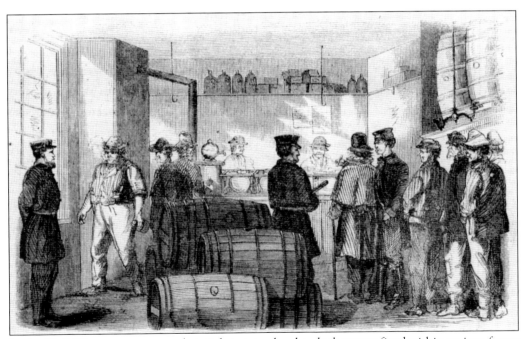

In the Civil War era, voters cast their tickets into glass bowls that were fixed within an iron frame (see of the center of this image from a polling place in Five Points). There was absolutely no secrecy in how one voted from the time a voter procured his ballot until he carried it through the crowd and cast it in the ballot box. (JW.)

Republicans wanted voters to see that they had a clear choice in the election. In this image, titled "Scene at the Polls in N.Y.—A Voter in the Hands of the Philistines," two Democratic operatives lead a drunken Irishman to the polls. Whether the voter got inebriated on his own or as the result of Democratic treating, the voter needed the assistance of the corrupt politicos to walk. (JW.)

In the companion image, "The Veterans of 1812 and 1864," *Frank Leslie's Illustrated Newspaper* depicted two wounded veterans—one from the War of 1812 and the other from the Civil War—walking arm in arm to vote for Lincoln. Their patriotic and heroic countenances stood in stark contrast to the drunken Democrat and the "Philistines." (JW.)

Some unscrupulous men attempted to vote more than once. *Frank Leslie's Illustrated Newspaper* reported that "a few industrious persons" tried to "vote early and vote often." When challenged, one man said that he "thought he had a right to vote twice, because he had not voted last election!" Another said that since he had been "married twice . . . he had a good right to vote twice." (JW.)

Horace Greeley's *New-York Tribune* urged Republicans to "do whatever you can to swell the poll of legal voters for the Union ticket." The Republicans' get-out-the-vote efforts included transporting wounded and convalescing soldiers to the polls, as this image from *Frank Leslie's Illustrated Newspaper*, "Bringing Invalid Soldiers to the Polls," depicts. (JW.)

Readers in London were curious to see what the election looked like. In one image, titled "A Polling-Place Among the 'Upper Ten,'" the *Illustrated London News* depicted a polling place in the office of a veterinary surgeon where "knots of the richer class of New York citizens—the Upper Ten Thousand, as they are called," can be seen "anxiously discussing the chances of the rival candidates." (JW.)

In a second image, titled "A Polling-Place Among the 'Lower Twenty,'" Londoners saw "the dirty and unwholesome districts of the city, where the hard-fisted classes chiefly make their abode." At Five Points, the police "were in strong force, and the liquor-shops were all closed—that is, the shutters of those dens of iniquity were up; but as the doors were open there was no difficulty in obtaining strong drink." (JW.)

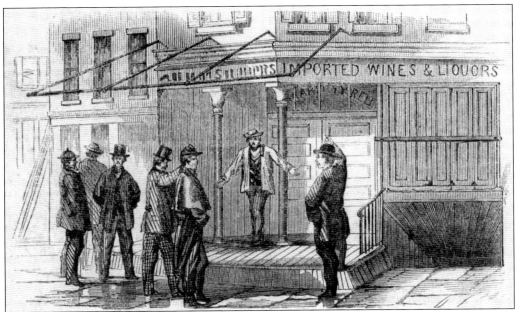

New York State law forbade the sale of liquor on Election Day, and on November 7, Police Supt. John A. Kennedy instructed the police to enforce the law. The *New York Times* praised the police for their efforts, reporting, "There was not even the ordinary drunkenness and rowdyism which attends the most unimportant elections in this city." In this image, a store owner refuses to sell liquor to patrons. (JW.)

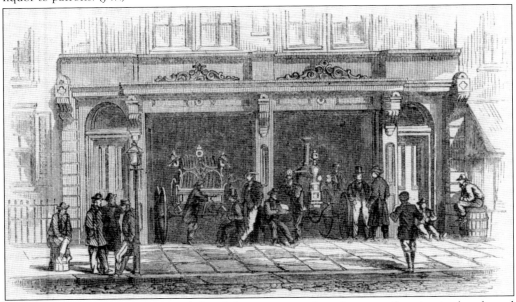

Shortly before the election, several Confederate agents plotted to start fires in city hotels and businesses. When Union officials caught wind of their plan, the rebels were forced to delay until after the election. Ultimately, these terrorist activities caused little damage, because their "Greek fire" was not highly combustible. This image from *Frank Leslie's Illustrated Newspaper* shows firemen on duty at an enginehouse "as a precaution against Rebel incendiaries." (JW.)

In 1864, New York authorized soldiers to mail ballots home, and soldiers' votes likely provided Lincoln's margin of victory in the state. In October, Democratic election commissioners stationed in Baltimore and Washington, DC, were arrested for mailing fraudulent ballots back to New York. This cartoon by Thomas Nast, titled "How the Copperheads Obtain Their Votes," depicts the commissioners perpetrating their fraud by using dead soldiers' names. (JW.)

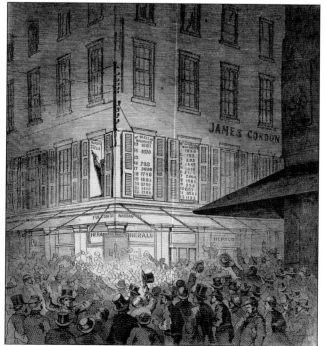

In the evening on November 8, voters gathered outside newspaper offices to await the returns. In this image, Democrats formed "an anxious and agitated crowd" outside the *New York Herald* office at the corner of Fulton and Nassau Streets. Lincoln handily won the election, winning roughly 55 percent of the national popular vote. In the Electoral College, Lincoln garnered 212 votes to McClellan's 21. (JW.)

Twelve

A City's Memories of War

The city's war ended on a sour note, as news of Abraham Lincoln's assassination spread across the nation. Although many New Yorkers had derided Lincoln's leadership, upon his death, they demanded justice to be meted out to his killers. Lawyer George Templeton Strong wrote in his diary that, "Above all, there is a profound, awe-stricken feeling that we are, as it were, in immediate presence of a fearful, gigantic crime, such as has not been committed in our day and can hardly be matched in history." The city offered Lincoln a beautiful send-off, parading his catafalque through the streets on April 25, 1865, in one of the city's largest-attended public funerals.

The city committed itself to Lincoln's work by honoring the war's dead and its veterans. Taking cues from ceremonies held in other cemeteries, New York City's veterans held yearly gatherings at Cypress Hills Cemetery and at Green-Wood Cemetery to decorate the graves of the dead with mayflowers. In 1873, the legislature in Albany declared this tradition, Decoration Day, as a state holiday. Every May 30, businesses were required to close and citizens were required to display flags in recognition of the sacrifice of Union soldiers and sailors. In the city, Civil War veterans participated in a massive parade, donning their uniforms and carrying their torn banners. Although they represented a small number, African Americans marched in this parade alongside their white comrades.

Over time, Decoration Day became known as Memorial Day, and Civil War veterans continued to participate in the city's parades into the years of the Great Depression. The Grand Army of the Republic assembled 32 veterans for the 1932 parade, 20 for the 1934 parade, and 10 for the 1939 parade. The last known New York City veteran was drummer James Albert Hard, who enlisted on May 31, 1861, as part of Company E, 32nd New York. A veteran of 16 engagements, Hard died on March 12, 1953, at the age of 109 and was buried in Rochester.

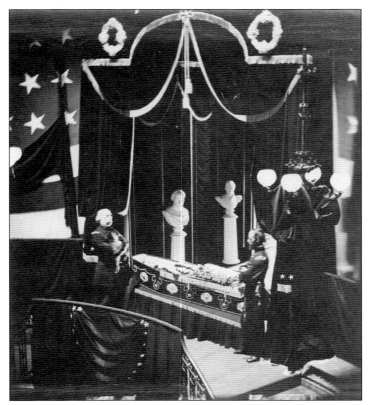

Lincoln's remains arrived in New York City at 11:00 a.m. on April 24, 1865, entering at the foot of Desbrosses Street via a Jersey City ferryboat. Police and soldiers guided Lincoln's hearse to City Hall, where the body would lie in state. Although Mary Lincoln forbade any postmortem photographs, Brig. Gen. Edward Davis Townsend allowed Jeremiah Gurney to take this image. Townsend stands to the right of the catafalque, and Rear Adm. Charles Henry Davis stands to the left. (ALPLM.)

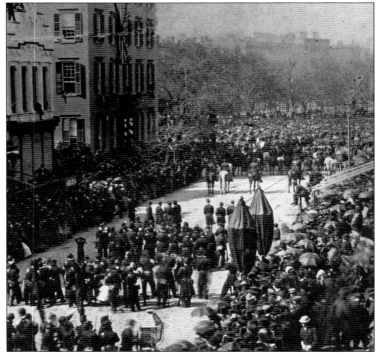

On April 25, the city hosted the martyred president's funeral procession, which involved over 60,000 participants. The convoy included police, militia, US senators, firefighters, foreign consuls, and longshoremen. Initially, the city council refused to allow African Americans to march, but after heated protest, 200 members of the 1st Loyal Colored League of Brooklyn received permission to participate. This photograph depicts the procession paused along Broadway. (NYPL.)

This image depicts the procession as it passed along Broadway. The funeral car, which was pulled by a team of 16 black-draped horses, is nearest the viewer. Twelve veteran soldiers, six per side, guided the horses. Members of the 7th New York State Militia surrounded the funeral car. Maj. Gen. John Adams Dix and his staff are ahead of the horses. Ahead of Dix are the remainder of the 7th New York State Militia, 960 officers and men under command of Col. Emmons Clark. (LOC.)

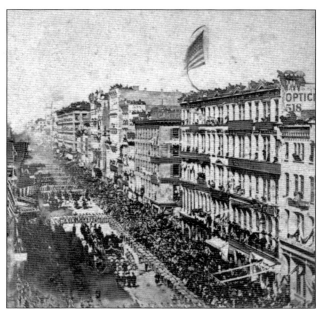

Following traditions set by other communities, New Yorkers gathered every May 30 for Decoration Day, a day of mourning to honor the Union dead. This illustration depicts Decoration Day 1869, when thousands gathered at Cypress Hills Cemetery in Brooklyn to pay respect to 3,000 gravesites. Maj. Gen. Alexander Shaler led the troops. Over 120 war orphans from the Union Home and School decorated the graves with flowers. (LFFC.)

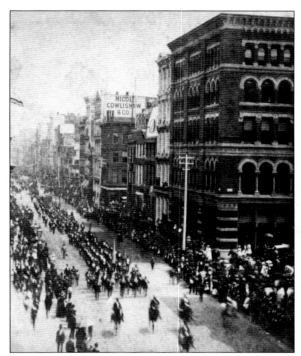

This photograph, taken from the corner of Broadway and Bond Street, depicts a Decoration Day parade held on May 30, 1875. By this point, commemorations had spread across the city, involving dozens of cemeteries and churches as well as ceremonies at the Lincoln and Farragut statues. (NYPL.)

In the 1880s, veterans began raising money to erect monuments upon Gettysburg's battlefield to mark the positions of their regiments. This image, taken on July 2, 1888, depicts veterans of the 40th New York at Devil's Den (the cluster of boulders in the background). Veterans and their families dedicated a $2,225 monument. The governments of New York and Massachusetts (which provided four companies to the regiment) defrayed some of the cost, but the rest came from the veterans themselves. (LOC.)

On October 10, 1888, the veterans of a German American regiment, the 45th New York, gathered at Gettysburg to dedicate a monument that marked the position held by their regiment. Pvt. Christian Boehm delivered the primary oration, concluding, "May this splendid monument stand for eternity and show posterity . . . that foreign-born people are also able to faithfully fulfill their duties for their adoptive fatherland, and when it comes down to it know how to boldly sacrifice their lives." (William L. Clements Library, University of Michigan, via Michael Waricher.)

In the 1870s, Black participation in Decoration Day parades tended to be sparse, but as the years passed, the number of participating Black veterans gradually increased. Each year, Black veterans constituted their own segregated division, which brought up the rear of parade. This photograph depicts the Memorial Day parade of 1912. That year, 750 New York City veterans participated in the procession. (LOC.)

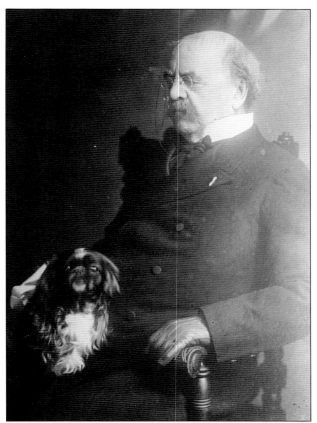

Following a turbulent career as minister to Spain, Daniel Sickles returned to New York City, moving into a four-story townhouse at 23 Fifth Avenue. He became a fixture in veterans' affairs, serving as a chairman on the New York Monuments Commission. This image depicts Sickles with his beloved pet, Bo-Bo, a Blenheim spaniel who had been gifted by the Duke of Marlborough. (LOC.)

Sickles died of a cerebral hemorrhage on May 5, 1914, at the age of 91. Three days later, his funeral took place at St. Patrick's Cathedral. Although Sickles had lived a controversial life, amassing many enemies, his death produced a funeral procession that rivaled Lincoln's. At 3:34 p.m., a train whisked Sickles's casket to Arlington National Cemetery, where it was buried. (LOC.)

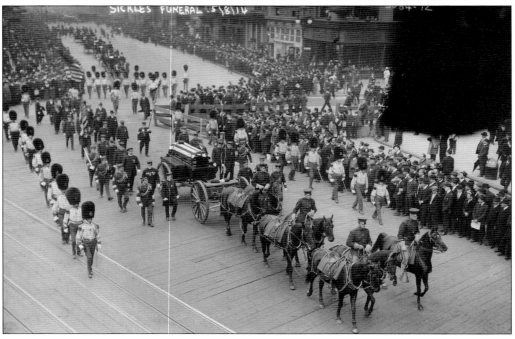

This image depicts the 1917 Memorial Day procession, which concluded at the Soldiers' and Sailors' Monument on Riverside Drive. Thinking of the Western Front, one reporter editorialized, "It may be that before next year many of the lean, strong lads in khaki who swung along yesterday as escort to the tottering file of the men of '61, may lie beneath the little flags and withering wreaths in the valiant fellowship of those who died that a nation might live." (LOC.)

This image depicts the 1918 Memorial Day Parade. The six men photographed here belonged to the 165th New York Volunteers (2nd Battalion, Duryée's Zouaves). The officer at the front is likely Lt. Matthias Johnston, who served for three years and was wounded at the Battle of Port Hudson. After the war, he lived in Brooklyn and managed a hotel called Byron Shades. This was one of Johnston's last public appearances. He died on March 18, 1919, at the age of 79. (NARA.)

Discover Thousands of Local History Books
Featuring Millions of Vintage Images

Arcadia Publishing, the leading local history publisher in the United States, is committed to making history accessible and meaningful through publishing books that celebrate and preserve the heritage of America's people and places.

Find more books like this at
www.arcadiapublishing.com

Search for your hometown history, your old stomping grounds, and even your favorite sports team.

Consistent with our mission to preserve history on a local level, this book was printed in South Carolina on American-made paper and manufactured entirely in the United States. Products carrying the accredited Forest Stewardship Council (FSC) label are printed on 100 percent FSC-certified paper.